Through An Open Door

Selections from the Robert A. Hefner III Collection of Contemporary Chinese Oil Paintings

Dedicated to Steven McLain Hefner and Kevin MacKenzie Ye
and their venture into the 21st Century

Published by Portfolio Editions

Essays by Robert A. Hefner III and Fan Dian

Photographs by Jon Burris

開放之門

Published in 1997 by Portfolio Editions, Oklahoma City, Oklahoma

Edited and Designed by Jon Burris

Printed in the United States of America
By Southwestern Printing, Oklahoma City, Oklahoma

ISBN 0-9656794-0-3 (HC) ISBN 0-9656794-1-1 (SC)

Library of Congress Catalog Number 97-65478

Contents

Introduction
Robert A. Hefner III

My collection began in 1985 while bouncing along some old dirt roads on the way to visit oil and gas fields in what seemed the middle of nowhere in Sichuan province, China. Everywhere we turned, we were surrounded by a budding economy; there were free markets, cottage industries of every sort and new homes going up on every farm. I was in the midst of a grass-roots economic awakening surrounded by an upwardly mobile peasant class. I knew then that Deng Xiaoping's post-Cultural Revolution reforms were irreversible and that this unprecedented growth was sure to continue into the 21st Century. These profound socioeconomic and cultural transformations in the world's most populous country were destined to become a defining moment in history. I believed China would soon change the world.

As I reflected on all that surrounded me, I was reminded of the Renaissance and the turn of the last century – other periods of revolutionary change that became so intensely influential and historically important to the arts. I immediately began to search out contemporary artists, and what I found was that a large group of extraordinarily talented painters had completely broken with the past; with thousands of years of traditional Chinese ink and watercolor painting. I found literally an explosion of creativity releasing itself through the medium of oil. These generally younger artists were not only well disciplined in the basic techniques of drawing and traditional Chinese brush painting, but also, nearly without exception, possessed a deep sense of their history, culture and philosophy. I believe their great determination to confront the age-old norms of Chinese painting, experiment with a new medium and initiate an entirely new movement in Chinese art were the result of equal measures of their own sense of participation in a defining moment of history and their personal rebound from the Cultural Revolution, which had for so long bottled up their intense creativity. Caught up in the high energy of the moment, and in support of their spirit and in admiration of their talents, I became an obsessive collector.

I made many visits to the academies where most artists were studying and teaching, and soon learned of the highly important Sixth National Art Exhibition (National Exhibitions are held every five years) in Beijing at the China National Museum of Fine Arts. The Sixth National Exhibition was the first to display

Robert A. Hefner III, Forbidden City, Beijing, 1995

~ 4 ~

a large body of contemporary oil paintings considered by the critics to be China's best and most important of the period.

I was stunned by the quality and diversity of the works, and to my surprise and delight, I learned that many of the paintings were for sale. It was then and there that my collection really began. My first purchase was *The Wish*, *1984*, a painting by Jian Feng, of a Sichuanese peasant boy holding his bicycle with empty baskets, who, having sold his produce in the free market and purchased books not available to students during the Cultural Revolution, is reading a wall poster, not of some revolutionary political slogan, but about where to seek continuing education. This painting represented to me all that I saw and felt in Sichuan Province that led to my decision to collect.

Another outstanding painting included in the Sixth National Exhibition was Luo Zhongli's *Father*, *1980*, a monumental memorial to the harshness of life endured by the peasant farmers of his native Sichuan province. Sadly, this painting had already been acquired by the National Museum. It was only later that I learned that this larger than life painting of a peasant farmer had caused a great sensation because it was the first work of art since the beginning of the People's

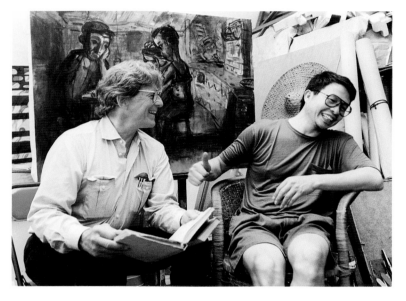

Robert A. Hefner III and Luo Zhongli in the artist's studio, Chongqing, 1995.

Republic to be painted in a heroic, larger than life size that was not of Mao Tse-tung. My profound reaction to this painting instilled in me a determination to go to Chongqing to meet the artist. A year later, I shall never forget walking into the Sichuan Academy and once again being struck by a deep emotional reaction to Luo Zhongli's second in his series of three larger than life paintings. I found myself standing face to face with *Spring Silkworms*, *1980*. In the old peasant woman harvesting her silk, I saw both the beginning of the end of old, classic China, and a clear indication of China's robust future. Unfortunately, on that trip the artist was off in the country painting and I was not able then to purchase either *Spring Silkworms* or his third piece in this series, *Father II*, *1982*, depicting a more robust man of the Earth than was the peasant of *Father*, who is blowing his horn in celebration of both the waning harshness of the past and the dawn of a more abundant future. I held no doubt that these three treasures were the work of a deeply emotional, highly talented artist, well grounded in his traditions and culture and were his summary statement of an electric moment in the history of his country's momentous transition. It was to be years later that I met Luo Zhongli to confirm in the man all that I saw in his

paintings and only in 1995 did *Spring Silkworms* and *Father II* become a permanent part of my collection.

During 1985 and 1986 I crisscrossed China visiting artists and museums and purchasing paintings. In those days the academies were of a standard Soviet-style cement block construction. The artists' studios were small and dark, stacked full of paintings neatly organized because of the very limited space. Lacking proper materials, the artists improvised, some making their own crude canvases. I immediately began to send to our artist friends proper canvases and paints from America. Their surroundings were obviously difficult, but those circumstances seemed only to spur on their enthusiasm and experimentation. Another

Harkness House Exhibition, New York City, April, 1987.

treasure-trove of paintings was to be found at the Chinese Artists' Association headquarters in Beijing. It was there that I met and soon became a friend of Hu Mingzhi, who later told me of his year-long pilgrimage following the Cultural Revolution to all the academies across the country, carrying with him the official word

to the artists, "You are free now to paint whatever you want!" The communication between the artists at that time seemed to far exceed their ability to use the telephone; knowledge of my collection and appreciation for contemporary oil painting now preceded me wherever I traveled. During my stay in 1986, the Artists' Association asked me if I would consider assembling the first major exhibition of contemporary Chinese oil paintings to be held outside China. I enthusiastically agreed. We then began considerable negotiations with the Ministry of Culture, which in those days had not yet been imbued with Deng's reforms, as it has today; nevertheless, we broke all records and opened in New York in April, 1987, what today has come to be known as the Harkness House Exhibition. The Artists' Association was charged with the responsibility of contacting artists, academies and museums from around the country to organize in Beijing a collection of several hundred outstanding works. I was given free reign to choose the paintings that would travel to America. Somewhat

daunted by the task, I knew I must establish a set of defining principles, not only for the Harkness House Exhibition, but for my own collection.

First, because of my deep belief in the historical significance of the times, I decided the works to be chosen should incorporate measures of China's history and cultural legacy; and equally important, paintings that told a story or were representative in some way of China's great socioeconomic and cultural transformation. Additionally, as I pondered my selections, I recalled what I once learned from a guide at the Frick Museum in New York. I was told that Mr. Frick's overriding principle was that he always collected paintings he could live with. Borrowing from Mr. Frick, all of the works in this collection are paintings with which I personally enjoy living. These tenets are the common thread of my collection. I will never forget the exciting moment of walking into a large warehouse hidden somewhere in the center of Beijing with my friend Hu Mingzhi to view several hundred paintings stacked in every corner, scattered across the floor, and hung on every available wall space. After two long days and conversations well into the night, I had selected over 100 works. It was during those days of planning that I also met with and chose paintings by many of the artists who are a part of this collection. We also traveled to Shanghai to view and choose from the first exhibition of contemporary oil paintings in that city. I was given the honor of joining President Jiang Zemin, then mayor of Shanghai, for the opening ceremony. Nearly as memorable as the paintings were the ten thousand white doves released on the occasion.

By the time the Harkness House Exhibition opened we had assembled over 200 works representing 73 painters from the People's Republic. We arranged for a few of the artists; Ai Xuan, Wang Yidong, Wang Huaiqing and Chen Yanning, to join us in New York to visit museums and attend the exhibition. Its success was truly gratifying. New York crowds flocked to the show in ever increasing numbers. At a time when much of the painting produced in the West, particularly in the United States, seemed to this collector either confused or intentionally shocking and difficult for the general public to interpret, our audience showed great enthusiasm for the representational quality and obvious talent of these Chinese artists. The critical reception in the press was very positive, but even more gratifying is the fact that the Harkness House Exhibition has become over time an historically defining event in the development of Chinese oil painting. Nearly half the paintings were sold and my promise to the Chinese Artists' Association to open up the market began to be realized. Today, the market is truly robust, with frequent auctions by Sotheby's and Christie's in Hong Kong and China Guardian in Beijing, as well as a proliferation of new sales galleries across Asia.

With the unsold paintings from the Harkness House and many new works, we opened Hefner Galleries to represent several of the more prominent artists. One man shows were held for Ai Xuan, Wang Yidong, Wang Huaiqing, Luo Erchun, Zhai Xinjian, Lin Hongji, Cao Liwei, Mao Lizi, Chen Yanning and He Datian, and in 1988, Hefner Galleries exhibited

and toured a body of works by Deng Lin, Deng Xiaoping's daughter, who is a leader in the movement to bring Expressionism to traditional brush painting.

Prior to the Harkness House Exhibition, contemporary Chinese oil painters were virtually unknown in the West, with the notable exception of Chen Yifei, who was then represented by Hammer Galleries. Because of the importance of the Harkness House Exhibition, Chen Yifei joined us, exhibiting one of his major works, *My View of History, 1979*. A painting from his now famous series of works depicting the ancient canals of Suzhou is included in this collection and a large body of Chen Yifei's recent works are currently on a world tour organized by Marlborough Fine Art of New York and London.

Contemporary Chinese oil painters, according to some Western critics, have simply copied Western styles. Of course, that is an arguable claim. However, one sees far too much of their own Chinese history, culture, unique tech-

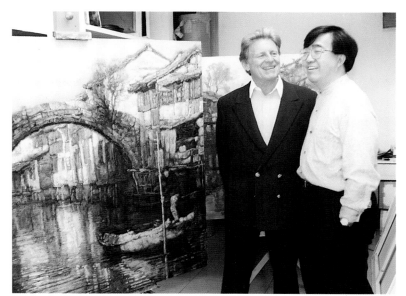
Robert A. Hefner III and Chen Yifei in the artist's studio, Shanghai, 1995.

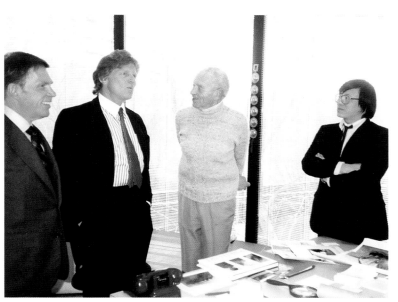
Roger D. Creelman, Director, Hefner Galleries, Robert A. Hefner III, Andrew Wyeth and Ai Xuan meet at the Wyeth home, Chadds Ford, Pennsylvania, 1988.

niques and traditional brush strokes for such a generality to hold credence. Rather, what I see is influence by and respect for the West's long history of oil painting. After all, this is one of the ways art develops.

What is certainly a defining difference between these Chinese artists and their Western counterparts is the depth and breadth of understanding of their country's five thousand years of history, philosophy and rich cultural tradition, and last, and certainly not least, for most of the artists in this collection, the trials and tribulations of their personal lives and unique history.

My favorite example of Western influence is that of Andrew Wyeth upon Ai Xuan. Ai Xuan told me that when he first saw a book of Wyeth's works, he was struck by a haunting similarity between the loneliness expressed through the starkness of the American artist's New England subject matter and that of his own loneliness, developed during the years of the Cultural Revolution when he was forced to live in

Tibet, and which he, too, expressed through the starkness of his paintings depicting life among the Tibetan people. Ai said to me that he believed there was a communion of their souls being expressed in their art. I took great satisfaction in bringing these two "soulmates" together during one of Ai Xuan's one man shows at Hefner Galleries. We spent a delightful day together during which I was able to introduce Ai Xuan to Andrew Wyeth, his wife Betsy, and son Jamie, at their Brandywine Museum. The artists spoke animatedly for hours and the experience was memorable for us all.

For me, a gratifying aspect of being a collector is the enjoyment of witnessing the artistic development of these painters. Wang Huaiqing has been exemplary in this regard. His art is typical of a common transition made from the representational *Artist's Mother, 1985*, to the more abstract style found in this collection in his architectural series of paintings depicting disjointed Ming furniture and the interior of old peasant homes -- *Unassembled, 1994*, and *Stage, 1995*.

Although one of my principal goals has been to capture the excitement of the post-Cultural Revolution period and thus, most of the works found in this collection were painted between 1979 and the early

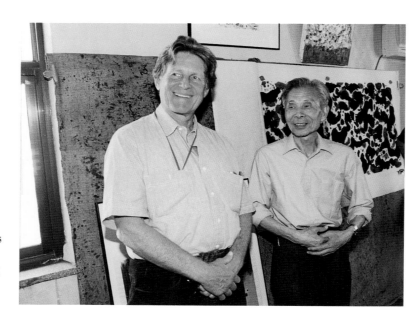

Robert A. Hefner III and Wu Guanzhong in the artist's home Beijing, 1995.

1990's, an exception is *Coming Out To Attack, 1964*. It can certainly be called a prime example of Socialist Realism, but I saw it as a work of great artistic merit as well as a painting towards which I had an immediate affinity. I later learned that the artist, He Kongde, was influenced by the Russian artist, Nicolai Fechin, whose works I also admire and have collected.

One of China's most important early oil painters and a teacher of both contemporary oil painting and abstract brush work is Wu Guanzhong. He is an exciting, vigorous man of 78 whose Yin and Yang of ancient tranquillity and spirit and energy fill his works. He has brought to Chinese brush, and oil painting alike, the insightful combination of traditional style and abstract form. He contributed works to both the Harkness House Exhibition and the 1988 Hefner Galleries/ Chinese Artists' Association show; another of his paintings, *Hometown of Lu Xun, 1972*, is a part of this collection.

Chen Yanning, another of our artists, once pointed out to me an interesting cycle of events. In ancient times in China that roughly correspond to the Renaissance era in the West, Chinese artists abstracted their calligraphy and poetry to the point it often could not be deciphered. Today, however, there

is much realism in Chinese art, similar to Western painters during the Renaissance, while art in the West is abstract to the point it often cannot be interpreted by the viewer. No doubt, the artists of our two cultures are telling us much more about our times and societies than we can fully comprehend.

When I started this collection I was truly moved by the exciting and creative body of work during the post-Cultural Revolution decade. Today, in the last decade of the 20th Century, I am just as thrilled by the continuing development of China's young artists and their insight into not only daily life in these historically unique times, but their own projection of China's 21st Century. We see in Cao Li's *Opened Notebook, 1995*, and *The Last Song, 1996*, not only a view of China's ancient culture and contemporary life, but a glimpse into her future. I am sure the future will prove these artists to have been just as visionary as artists throughout history.

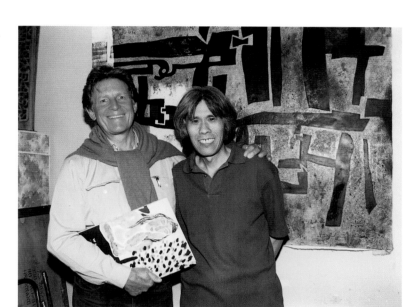

Robert A. Hefner III and Wang Huaiqing in the artist's studio Beijing, 1995.

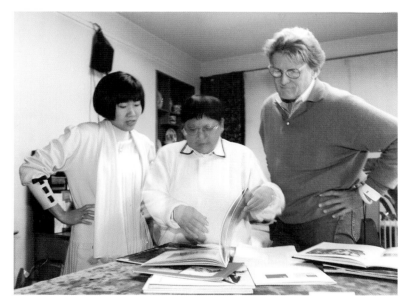

Lisa Lai, Deng Lin and Robert A. Hefner III look at catalogs produced for international exhibitions of Deng's paintings in the artist's studio, Beijing, 1995.

Among the great pleasures and most enlightening experiences of my annual pilgrimages to collect art and do business in China has been my acquaintance and, in many cases, friendship with these artists. For me, they have become an important and accurate source of insight into their country, its contemporary culture and its rapidly changing future.

My hope is that this collection endures as an exceptional representation of the souls, passions and expressions of these artists during one of history's greatest upheavals, and that these works will be viewed as a glimpse into a profound moment in the development of the world's art. But most of all, it is my overriding desire that *Through An Open Door* adds another small span to the bridge of understanding between our great cultures; a bridge whose strength and breadth will be so fundamentally important to peace and prosperity in the 21st Century.

The Changing Face of China
The Hefner Collection, 1985- 1996

Jon Burris, Curator

To see is easy, to learn is more difficult.

Chinese Proverb

To effectively seize a moment in history and make it one's own involves realizing the difference between that which is unique and of quality, and that which is only new and undefined. To a businessman it can mean the difference between success and loss. To a collector of art, it sets him apart from those who merely acquire. Robert A. Hefner III understood this in 1985 when he stood before a collection of oil paintings by contemporary Chinese artists assembled for the Sixth National Exhibition, Beijing. Because of his knowledge of art history and his interest in Chinese culture, he knew what he was seeing represented a dramatic shift, both ideologically and aesthetically, away from traditional Chinese art and not simply because the artists were dealing almost exclusively with oil on canvas as opposed to watercolor and ink on paper. Considering the enormity of other social and political changes that were underway in post-Cultural Revolutionary China, he sensed the virtual "explosion of creativity" he was witnessing would have long lasting effects. Both as a businessman and collector, he decided to act upon his instincts. He was right.

Over the twelve years since Robert Hefner

acquired his first piece for the collection, *The Wish, 1984 b*y Jian Feng (page 69), Chinese oil painting has developed at an amazing pace and has established itself internationally, influenced to a great degree by Hefner's activities. The ground breaking Harkness House Exhibition he presented in New York in April of 1987, introduced this art to the Western world thus creating a market that was previously nonexistent. Speaking of this event, critics and professors at Beijing's Central Academy of Art have described how excited students came running into classes with newspaper reports of the exhibition, exclaiming, "Oil painting in China has a future now that the rest of the world knows of us!" At this time in their history, such exposure in the West was important to the Chinese artists. While one or two had gained recognition in the United States, most were unrecognized internationally.

Following the success of the Harkness House exhibition, Robert Hefner opened the first New York gallery that represented exclusively, contemporary Chinese artists. From September of 1987 through June of 1989, he presented a series of one-man shows with a second group exhibition for the Chinese Artists'

Ancient South Gate Overlooking New Highrises, Beijing 1995

Association in 1988 (the first being the Harkness House Exhibition, which had been organized at the request of the CAA). In a review in the *The Wall Street Journal* in December of 1987, an American critic writing about the series of ongoing exhibits at Hefner Galleries said, "The new Chinese art bears as little resemblance to the subtle expressions of traditional ink-and-brush landscapes as to the propagandistic socialist realism mandated by Mao. It's the result of finely trained painters reveling in new-found freedom." While this assessment was true for the most part, this work was far more complex. One had only to study the astute blending of styles and controlled brush strokes of Wu Guanzhong's *Hometown of Lu Xun, 1972* (page 113) to realize that the artists were concerned, certainly on one level, with maintaining a Chinese viewpoint. To look at Wang Huaiqing's *Artist's Mother, 1985* (page 105) with its multi-level perspective of the subject and monochromatic pallet akin to

Hometown of Lu Xun, 1972,
by Wu Guanzhong
Oil on Board, 12 1/2 x 9 inches

that of a traditional watercolor, further challenges any idea that they had abandoned their classical training. Wang has said of this painting, "The woman in the picture was the mother of my neighbor, Zhou Huaiming who was a well-known and respected brush painter in China. It is a tribute to him so my message in this piece is very Oriental, very spiritual. The perspective, like that of traditional Chinese painting, allows you to see the portrait from different angles."

(Not coincidentally, Wang Huaiqing was a student of Wu Guanzhong's, who had studied in Paris in the late 1940s, returning to China to teach Western oil painting techniques in the art academies).

In regards of the paintings being shown at Hefner Galleries in 1987, the subtle blending of cultures and stylistic experimentation, with a concentration on the portrait and landscape, was representative of what Chinese critics termed Romantic Realism or Country Realism. It represented a move away from a "collective social" point of view, towards a more personal, introspective one. When Robert Hefner first discovered them, many of the artists who are now a part of his collection were just beginning this period of experimentation and freedom in the arts that followed the most devastating and disruptive years in all of Chinese history, those of the Cultural Revolution (1966-1976). During this time, many had been persecuted and sent away to hard labor and rehabilitation. Their studies had come to an abrupt halt and for most, there was no opportunity to have any direct contact with the arts. It is difficult in a Western sensibility to truly understand what they had endured, yet each of the artists found ways to survive these difficult years and resume their work after 1976. As Fan Dian points out in his essay in this book, it was a time when the artists were eager to escape political ideology and find their way back to "the truth in art."

As with the whole of Chinese life, art in the 1980s was opening to the rest of the world, searching for identity and slowly assimilating that in Western culture which was of use. A common issue that is raised regarding post-Cultural Revolution Chinese oil painting, is that of Western, or more specifically, European stylistic influence. Some critics have suggested that there is too much dependance on imitation; that Chinese portraits look a lot like Renaissance examples or landscape pictures borrow too heavily from Impressionist works. To understand why this is, we must first understand something about Chinese thought. Typically in the West, students of art are encouraged to be original above all else, even at the expense of learning what Chinese artists refer to often as "the basic principles." Having been highly diciplined in drafting and having been required to copy masterworks of Chinese art in school, many of the contemporary artists felt the best way to learn to use a new medium, was by practicing it in a style other oil painters had used. The Chinese call it *"fang"* or the art of imitation and it has been used in their arts for centuries.

What the Chinese oil painters were interested in studying in the academies prior to the Cultural Revolution, had more to do with the physicality of painting or what is called materials and methods. They learned how classical artists had used the medium technically, but their selection of subject matter was, for the most part, still directed towards political ideology. It only makes sense that by the time they were given freedom over such ideology, and by the time they began to see actual examples of art from the West, they would take as their example, that which they could respect for its quality, and beauty.

In the early to mid-1980s, Chinese artists freely explored all genres from Impressionism (*Boat Carrying Grass, 1987* by Lin Hongji, page 81) to Cubism (*Peking Opera, date unknown* by Wu Dayu, page 111), from Surrealism (*White House, Shadow of a Tree, 1985* by Cao Liwei, page 41) to Pop Art (*Ancient China, 1986* by Mao Lizi, page 97). Interestingly enough, at the same time in the United States and Europe, a trend to Post-Modernism, was by its very definition, "recycling" all of the previously mentioned genres of art, if in a much less respectable and more haphazard fashion.

The first exhibitions of Western art presented in China, as a result of the U.S./ China Open Door policy, began in 1981. The Boston Museum sent works from their permanent collection of Impressionists paintings. This was followed by traveling shows by well known individual artists such as Robert Rauschenburg and Andrew Wyeth that arrived in the mid 1980s. In particular, the Wyeth retrospective caused a cultural phenomenon unlike any that has come afterwards. In this American artist, the Chinese painters have said they found, "a poetic style to which they could relate… a sense of oneness with nature and respect for the individual." In the atmosphere of post-Cultural Revolutionary China, it was close to a spiritual awakening and it left a deep impression on many of the artists that exists to this day. One who Robert Hefner began to steadily acquire paintings from was

Ai Xuan. Ai has said that he understood the loneliness and longing in Wyeth's paintings and that he had a need to say the same things Wyeth was saying, to express the same emotions he had never been allowed.

Perhaps another reason the Chinese artists related to Wyeth can be found in their fascination with subjects that reflected life far away from the crowded urban centers in which they lived. The term "Country Realism" was coined to describe this movement that had its beginnings in the early 1980s and reflected the honest lives of everyday farmers and peasants in the serenity of the countryside. Among the most notable examples of this type of art Robert Hefner saw while touring the China National Gallery, Beijing in 1985, was Luo Zhongli's *Father*; an oversized, close-cropped, Photo Realist interpretation of a weathered farmer. The story of Hefner's association with this now recognized national treasure and his acquisition of Luo's *Father II* (page 89) is indicative of how this collection has developed over time.

Luo Zhongli has said that he painted *Father* in 1980 as a summation of his feelings about the people he grew up around in Sichuan province. "During the Cultural Revolution I was required to paint a lot of political pictures in a large, heroic size including many portraits of Mao Tse-tung. I decided after the Cultural Revolution, when I was free to paint what I wanted, I would create a similar portrait of a farmer. I knew I had never seen a painting this large of a peasant, but I honestly had no idea it would cause a sensation when it was exhibited. Technically, it is a little different from the Mao paintings and I borrowed the style

from something I saw in a magazine by the American Photo Realist painter Chuck Close."

The painting caused a stir in Chinese art circles as the selection of the subject was highly unusual, and obviously close to the size once reserved for portraits of historical heroes and government leaders. In accordance with the new openness however, it became symbolic of the recently declared freedom in the arts and it was brought into the collection of the prestigious China National Gallery.

Based on the popularity of *Father*, Luo created a second oversize work, *Spring Silkworms, 1980* (page 95), this time showing an old woman harvesting silk in a traditional Chinese method. The painting was first exhibited at the Sichuan Fine Arts Institute, Chongqing, where the artist was teaching and it immediately became an attraction. In fact, it is said that when Henry Kissinger visited China, he requested to travel to Chongqing to see the painting after having seen *Father* in Beijing.

A third piece in this now famous trilogy, *Father II* was produced in 1982. Of it, the artist has said, "The title was originally *Golden Harvest* because the old man in the picture is taking part in a festival and blowing a traditional suona horn."

Realizing the importance of these three paintings, Robert Hefner made a special request to borrow them for the Harkness House Exhibition in New York in April of 1987. The Chinese Artists' Association agreed the exhibition would be of major significance and arranged to loan the works only for the duration of the month-long show. Hung on opposite ends of a sixty

foot gallery, *Father* and *Father II*, each measuring nearly 8' x 5', were of a commanding presence, while *Spring Silkworms* became the focal point of a second gallery room. American audiences were in awe. On the final day of the exhibition, an excited young woman, baggage in hand, came rushing into the galleries and asked to see *Spring Silkworms*. Standing in front of it she said, "I'm so glad I made it here today. I went all the way to Chongqing to see this painting, only to find out an American collector had talked the Chinese out of it!"

At the close of the exhibition, Hefners' dilemma was how he was going to acquire the Luo Zhongli paintings. We discussed the fact that the Chinese Artists' Association would not likely entertain an offer to purchase them which turned out to be the case. The suggestion was then to organize a traveling exhibition for which the three paintings would serve as centerpieces. This plan was approved. While the paintings were variously exhibited over two years at Hefner Galleries, we decided it would not be safe to circulate them. Serious negotiations for their purchase began, with Lisa Lai, one of Robert Hefners' early Chinese business associates acting as liaison, but it was clear that the original *Father* was not for sale and had to be returned to the China National Gallery.

Between 1989 and 1995, talks continued. Finally, it was decided that we must sit down with the artist in Chongqing and determine what was best for the future of the paintings. In June of 1995, ten years after having first seen *Father* in Beijing, Hefner met with Luo Zhongli in the artist's studio at the Sichuan Fine Arts Institute. He explained how the two paintings were central to the focus of the collection and how they represented the spirit and vitality of contemporary Chinese oil painting as he had discovered it in 1985. He described his plans for an exhibition of his collection which would travel to museums in the United States, and hopefully, one day return to China allowing audiences in both countries to see *Father II* and *Spring Silkworms* in the context of other work produced during one of the most exciting periods in all of Chinese art history. Luo Zhongli agreed, saying that he admired what Hefner had done for all of the Chinese artists and that the two paintings belonged in the collection.

Robert Hefner has often acknowledged that he has never purchased a painting that didn't give him pleasure or that he couldn't live with on a daily basis. More literally, he has never acquired pieces simply for the purpose of relating them to other works, but he has consciously attempted to show a variety of approaches which the Chinese artists have taken. The earliest dated work in the collection, *Coming Out To Attack, 1964* by He Kongde (page 67) is a good example of the Socialist Realist style mandated by Russian instructors in the academies in the mid-1950s. He Kongde has recalled that while he didn't agree altogether with the course of teaching he received at the Central Academy of Fine Arts at that time, he did "share aesthetic feelings" with one Russian artist, Nicolai Fechin, whose works he saw in books. Hefner has especially appreciated this reference as he owns a Fechin painting.

Although separated by twenty years, Li Binggang's *People's Own Army, 1984* (page 75) is also reminiscent of Socialist Realism in both its theme and style. It pays tribute to the heroism of the People's Liberation Army who searched for survivors in the aftermath of a devastating earthquake in the city of Tianjian in 1976. The artist has expertly used the unique qualities of oil to create a surface texture that emphasizes the roughness of the scene. Within the framework of the collection, both of these paintings represent important transitional works, Li Binggang's being perhaps the last vestige of a vanishing style.

Confident of their abilities and freedoms in the late 1980s, the Chinese oil painters began to separate into more definitive schools, some settling into positions at the fine art academies where they had once studied. In Beijing, Wang Yidong and Yang Feiyun, teaching at the Central Academy of Fine Arts, moved in a more academic direction, concentrating on a neo-classical style of portraiture. They studied European masters, Wang Yidong in particular, focusing on art from the Renaissance. His *South China Woman, 1988* (page 107) is an exquisite representation of his paintings from this period; delicate and precisely rendered. Yang Feiyuns' style could more accurately be called neo-realist or modernist. Interested in the subtle gesture found in what French photographer Cartier-Bresson described as, "the decisive moment" he chose as his main subject, his wife, also an oil painter. *Instantaneous Static, 1990* (page 123) is an extremely straightforward portrait, signifying nothing more than an instant realized between artist and model.

In Hangzhou, teaching at the Academy of Fine Arts, Xu Mangyao pursued a realist/surrealist look in his work. He says that he was first influenced to paint near life-sized figures on canvas, by sculptures he saw in Italian museums and by images that recurred in dreams. At the 1988 Chinese Artists' Association exhibition at Hefner Galleries, he introduced *My Dream, 1988*, the first painting in what would become a series built around the theme of figures passing through, or alternately restrained by walls. *Young Scholar, 1989* (page 117) quickly became an easy target for critics and even colleagues eager to attach political connotations to the work in view of the conflict at Tiananmen Square the same year. However, in an interview conducted in June of 1995, the artist stated that he couldn't have had that in mind when he created the piece as it was made prior to the student demonstrations. He says that he was simply attempting to comment on the state of communication between the East and the West.

Into the 1990s a younger generation of painters, dealing with issues of contemporary life, have begun to comment on the responsibility of art to make a statement about the conditions of their rapidly changing society. Bringing these artists into the collection, Robert Hefner has viewed this as a continuation of the spirit first exhibited by the previous generation, never losing sight of the elements of quality and character in the art . Kuang Jian, born in 1961, didn't even begin to study oil painting until 1974, at the very end of the Cultural Revolution. Traveling to far western China to find the model for *Sunshine of Pamir, 1994,* (page 71)

is indicative of earlier artists' interest in the minorities spread throughout this vast country, and their sense of adventure in searching out these subjects. However, only one year later, Kuang restlessly shifted his attention to a young urban woman for a surreal portrait entitled *Dislocation, 1995* (page 73). In describing the piece he said, "I am trying to express the reality of life in China today. For instance, economic reform in our country has affected different people in different ways and some don't know how to respond to it. They don't know which way they should go with their lives or the possibilities that are available to them so it's as if they are dislocated in society." Clearly, the questions the younger generation of artists feel free to ask, have no answers for the moment.

The future for the Chinese oil painters whose works comprise this collection is far more assured than it was twelve years ago. Because of Robert Hefner, they have gained exposure critical to their development. A market exists now for their work, not only in the West, but in their own country which is moving headlong into the next century, with every indication of becoming one of the most prosperous nations on earth. Corporate collections, unheard of in the early 1980s, now utilize the auctions which have become standard sales venues for the contemporary oil painters and major cities such as Shanghai and Singapore have opened contemporary museums

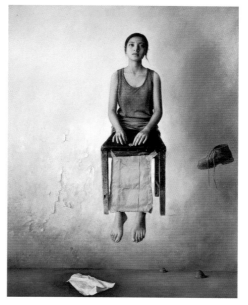

Dislocation, 1995, by Kuang Jian
Oil On Canvas, 57 x 44 inches

that rival any in America. The new Shanghai Museum of Art and the China National Museum, Beijing recently co-sponsored a retrospective for Shanghai born painter Chen Yifei.

Wang Huaiqing, mentioned earlier, is perhaps best representative of how the Chinese oil painters have managed, in the conflict of their times, to search out their own identity while attempting to preserve the positive aspects of their past; arriving at a unique blend of Eastern and Western cultures and philosophy, expressed in a whole new style of art. His architecture and furniture series (*Unassembled, 1994,* page 102 and *Stage, 1995,* page 103), produced in abstraction, focuses on traditional subject matter with a modernist's eye. In *Unassembled,* he explodes a Ming chair, showing us more than the sum of its parts forcing us to question what we think we see. When asked for a description of the painting, Huaiqing said, "It's not exactly about the chair, it's more about the philosophy behind ancient Chinese architecture combined with my ideas of the future of Chinese art." Similarly, it could be said of Robert Hefner; what he identified in the contemporary Chinese oil paintings he first saw in 1985 was not exactly about portraits or landscapes or still lifes, it was about the future of an entire culture and how it would be changed by the ideas and the spirit of the individuals who created its art.

Through An Open Door
Oil Painting In China in the 1980s

Fan Dian

The first time I saw the contemporary Chinese paintings from the Hefner Collection which are included in this book, I had an intimate feeling because most of the artists are my friends and colleagues. I have seen many of the paintings reproduced here in exhibitions throughout China and have even witnessed their birth and discussed them with the artists in their studios. In terms of quantity, the paintings in this collection represent only a part of the overall picture of contemporary Chinese art in the 1980s. However, in regards of their artistic characteristics and their cultural connotation, they are representative of important trends in the development of contemporary Chinese oil painting during this most important transitional decade. Though there are limitations for any kind of collection, the significance of these paintings greatly exceeds any reference to quantity when the process of collecting parallels such an important period in art history. In this case the part may reveal the whole when the process itself becomes a creative endeavor.

The term "oil painting" in the modern Western world has become out of date because materials alone no longer give art meaning. Any media can express an artistic concept. But compared to other kinds of painting such as traditional Chinese water color, oil painting can express a greater realism and perhaps richer artistic ideas. As a result, the Chinese have become more interested in oil painting and it has assumed a place in Chinese life. It will not retreat from the historical stage.

It is inevitable that we define the 1980s as the turning-point for Chinese oil painting though the study of art history does not necessarily follow the time table of political changes. Since 1949, art, literature, and especially oil painting have always been components of national ideology and tools of public ideological education. Owing to its realistic capabilities, oil painting has often been utilized to promote political themes. The "Great Cultural Revolution" drove Chinese literature and other art to the extreme and oil painting became a fixed mode. Artists who had been engaged in oil painting for years were suddenly forced to stop work and their normal course of study was terminated.

Only paintings that advocated the Cultural Revolution were supported. Therefore, immediately following the Cultural Revolution, the first inclination of most Chinese artists was towards a recovery of artistic sensibilities. In this way, the Chinese political democratization brought about the liberation of oil painting.

At the beginning of the 1980s, Chinese oil painting entered a new developmental stage. The term Country Realism is very appropriate in describing this turning point. It maintained the concept of Realism which symbolized the main stream of Chinese oil painting in the first 70 years of the 20th Century with a modifier "country" to represent changes in the individual artists' feelings. There is another important historical factor, an oil painting by an Italian priest in the 16th Century, presented to the Chinese emperor of the Ming Dynasty, may well be the earliest recorded painting that came to China from the Western world. There were in fact oil painting activities in the courts of both the Ming and Qing dynasties for 300 years, but the end of the 19th Century is recognized as the period when the Chinese began learning oil painting techniques from Western artists.

Compared to the long history of Chinese traditional painting, oil painting becomes an absolutely different model in regards to an observation of nature. Chinese painters spent centuries mastering the basics of this genre, whereas Chinese society as a whole took centuries to accept it. Due to the inertia of Chinese traditions and the chaotic background of civil wars in the first half of the 20th Century, Realism

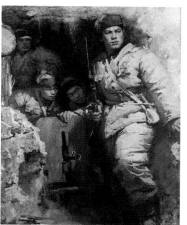

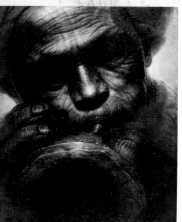

became the choice of artists from among various styles of painting that filtered in from the West.

Unfortunately, during the period of the Cultural Revolution, Realism became Political Realism and the works of the oil painters turned into posters of political idols. In the early 1980s, a major topic in Chinese oil painting society was how to rid itself of politics and recover truth in art. Having suffered the chaos of the social system, the deterioration of morals and the loss of humanity during the Cultural Revolution, most painters believed that the conscience of artists could be expressed only through a realistic interpretation of their subjects. They also believed their art should be rooted in their life and cultural heritage. Many expressive and truthful pictures, especially those showing workers, were based on these feelings. The artists were eager to show that humanity is made up of individuals whose emotions and real beliefs had become distorted by the Cultural Revolution. Country Realism here refers to a visual expression that painters derived after exploring all levels of Chinese society, but their pictures often described ordinary life.

There were in fact, two tendencies at this turning point. The first was to express the reality of farmers' lives. In China, farmers are a major part of society; they are the most

diligent laborers and the embodiment of honesty and virtue.

In 1980, the artist Luo Zhongli painted a huge portrait of a farmer which he entitled *Father*. In his mind, the image of someone who had been through the vicissitudes of life was a symbol of the elder generation. The painting stirred up extensive debates in art circles not simply because he had chosen to paint an ordinary farmer, but because such scale, a little over 8'x5', was normally reserved for political leaders. He also produced *Spring Silkworms, 1980* (page 95) in oversize proportions, and later created a variant of *Father* which he called *Father II, 1982* (page 89). The subject of *Spring Silkworms* is an old woman, her lowered head covers her countenance, but her wrinkled hands are full of expression. Her silvery hair, which is the focal point of the portrait, is glittering golden against a dim background. What is clear in these portraits is that the artist has a deep affection for his peasant subjects.

In truth, the work of Luo Zhongli is the result of his life experience in the countryside of Sichuan Province in the southwestern part of China, but many other "urban" painters have gone to the remote frontier or deep into the countryside to find their subjects. Zhan Jianjun has produced portraits of the Tajik people from the Xinjiang Autonomous region such as *Old Man from the North, 1981* (page 129) and *Tajik Old Man, 1981* (page 131) and Ai Xuan has drawn on source material from Tibet for many years now as seen in his *Winter Afternoon, 1988* (page 29), *February In An-Qu Village, 1988* (page 30) and *The Seasonal Wind*

at Nuo Ergai Tibet, 1982 (page 31). Both painters have stated they have interest in subjects far away from the modern cities because they can feel the warmth and tranquility of those people who remain uncontaminated by modern civilization.

A second tendency in Country Realism is towards the landscape of which there are several fine examples in the Hefner Collection. In fact, I believe they are the best examples of this genre from the 1980s and represent a desire on the part of at least a few of the oil painters to return to nature. Such pieces as He Jiancheng's *Original Shape #8, 1987* (page 65) or Lin Hongji's *Boat Carrying Grass, 1987* (page 81) illustrate simple, peaceful scenes. It is not difficult to understand the artists' intentions, historically Chinese Intellectual painting emphasized the implicitness of unconventional simplicity. Away from the hustle and bustle of modern civilization, the painter finds his own virtual Eden in the country.

To some extent, realism in Chinese oil painting today is the result of the artists' education. Without exception, the painters represented here are graduates of major art institutes throughout China. Some have gone on to become teachers in these schools. The dual role of teacher/artist reminds us of the European academic painters of the 18th and 19th centuries. Only those who received such extensive education acquired the abilities necessary to paint proficiently in oil. This kind of academic criteria has become something of a standard in oil painting and Chinese oil painting in particular, evolved from this mode.

During the late 19th and early 20th Centuries,

many of the pioneers of Chinese oil painting went to Europe, Japan and America to receive a Western education. They studied classical oil painting techniques and experienced first hand, the trends towards modernization. The important mission of those who returned home before 1949 was to disseminate what they had learned through their teachings. Unfortunately, because of the backward condition of education on the whole, the level of Chinese oil painting was staggeringly primative. After 1949, the government officially sent a large number of students to the Soviet Union while inviting Russian educators to lecture in China. However, under the influence of politics, the Chinese oil painters were directed away from the European classical tradition. The roughness of this early work is obvious, even if the artists maintained their enthusiasm.

Art education once depended on historical example through the study of original works of art. But before the 1970s, there was not one single "Western" oil painting in any collection in China. Young students could not go abroad either and political isolation prohibited exhibitions being brought to China. There were few books on oil painting in any libraries. This became a major problem in education and consequently the Chinese painters accepted the fact that their knowledge of oil painting during these years was, for the most part, naive and far away from any original connotation. Because of this lack of education, the practice of oil painting until the 1970s consisted, in the simplest of terms, of producing color pictures on canvas in support of political themes.

By the 1980s, following the Cultural Revolution, young painters became discontented with this backward situation. They abandonded political subjects and focused on a variety of approaches to studying oil painting. They advocated learning from the true masters of art. They skipped any study of Western oil painting in the 19th Century and instead pursued the period of the Renaissance in order to seek the "origin" of oil painting. Russian paintings once used as examples were put aside and the work of Leonardo Da Vinci and Rembrandt became the new models. When exhibitions from the West finally began to enter China, artists came from all over the country to see them. They paid special attention to drawing skills as opposed to subject matter. They studied the way canvases were prepared, the use of different materials and mediums, and the way Western artists used multiple layers of paint.

In this collection, we may look at three painters

as examples of how all the artists learned from the masters. Wang Yidong is represented by three portraits, all strong profiles. In one, he depicts a farmer from his hometown (*Profile of Old Man, 1986*, page 109) but he has idealized the subject, stressing the powerfull outline of his profile. This style is reminiscent of the portraits of aristocrats painted by early Renaissance artists.

The second painter, Yang Feiyun, whose piece *Artist's Wife with Her Dog, 1989* (page 121) is most typical of all his work, portrays a seated woman against a dusky background, again like a picture from the Renaissance. What he seeks is elegance so his modeling is rather simple. The figure in the picture expresses a kind of steadiness like a pyramid. In order to highlight the subject, he treats the background like an empty space formed only by color so as to delineate the figure. In this way, Yang's painting is distinguished from others as he relies on natural colors to make his paintings as close to reality as possible, emphasizing the feeling of skin and clothing.

The third, Zhai Xinjian in his *Ancient Mural, 1987* (page 97) depicts a contemporary woman in the foreground but hints at more classical Chinese art with the addition of the historical mural in the background. This practice is quite typical of Chinese oil painting as the artists attempt to say that learning from their masters is only a wish but the ideal state of the masters cannot be restored. They believe however, by blending their cultural heritage with what they have learned, they can create a new form of Chinese oil painting. Such study of classical art and the mixing of themes represents a cultural choice and these new painters are perhaps more rational than enthusiatic.

The inner-most feelings an artist has when he creates an image are often the key to understanding the implication of his work over time. Art critics and historians will learn about the cultural characteristics of an era by studying its art. In the Hefner Collection, there are two paintings by Xu Mangyao; *Young Scholar, 1989* (page 117) and *Young Woman, 1989* (page 119). Both depict subjects who struggle to get away from the confinement of a wall. This painter indulges in images that exist both in reality and in his mind. From the 1980s through the 1990s, he has painted pictures using a wall, describing spaces separated and lives constricted by separation. The implication of a "wall" as a barrier to the communication and thoughts of different cultures is quite obvious.

Prior to the 1980s, there had been a long period of separation between Chinese and Western cultures. Chinese art was "separated" from Western art. Impressionism was regarded as being representative of western formalism and so on. Developments in western art in general were kept away from Chinese artists and during the Cultural Revolution, the entire field of oil painting went into a fixed mode. It wasn't until the Open Door policy was put into effect that real cultural exchanges were possible. Since the 1980s though, a great deal of information about contemporary art has been introduced and this has had a significant impact on Chinese painting in general. In 1981, the Boston Museum exhibited a collection of oil paintings in Beijing and Shanghai. It was the first time Chinese

painters had a chance to see real developments in Western art from early Modernism to Abstract Expressionism. After that, there came many other exhibitions dealing with Cubism, Surrealism and Pop art. Various catalogs and literary works on Western contemporary art were translated into Chinese and they had a great influence on the artists of the younger generation. They began to realize they were rather narrow-minded in their ideology so they turned their attention inward, questioning what they knew. They recognized the contradictions between man and his world as he experienced the process of social transformation. They also considered common problems our cultures faced.

In the mid-1980s, the painters of the younger generation started engaging themselves in all sorts of experimental art activities. According to a rough estimate, by 1986, there appeared hundreds of young artists' groups. These organizations made declarations stating that their art was the expression of their thoughts and their inner world and was based on the philosophies of Nietzsche, Sartre and Freud. Soon, there were many "Chinese" examples of Expressionism, Symbolism, Surrealism and Abstract art. In terms of artistic standards, there were not many outstanding paintings born of this trend. However,

such a dialogue with Western art was valuable in regards to a cultural transformation that was taking place. It has been speculated that during this short ten year period, Chinese oil painting experienced the one hundred year process of development that Western art went through! In 1982 there were heated debates over the existence of beauty in abstract art, but by 1992, works of abstract style had become a socially accepted fact.

Work by the artist Mao Lizi in this collection illustrates the use of modern style and thought in Chinese painting. In *Departure, 1988* (page 99) he uses the concept of "ready-made products" that relate to ordinary life. When he creates these images he does not consider their social significance, instead, he emphasizes his personal recognition of them, placing his initials MLZ conspicuously in the painting to express the value of his own existence. Similarly, *White House, Shadow of a Tree, 1985* (page 41) by Cao Liwei can be regarded as the Chinese model of Surrealism. The artist has been to the northwestern part of China where he saw a lonely sight on the plateau. He did not paint realistically what he saw — a wild and wasted landscape — instead he conveyed his sentiment in an illusive image. Wu Dayu was an elder painter in his 80s when

he produced *Peking Opera, date unknown* (page 111). In it, we sense the influence of Cubism and Expressionism. It is quite significant that this artist represents these styles in this painting thought to have been produced in the mid-1980s as he probably dreamed of being able to paint this in his younger days. The first movement towards modern art in China actually occurred in the 1930s. A large group of artists in Shanghai advocated "art for art" and was against "art for society". They took the name *The Largest Wave* and purposely promoted the styles of Cubism, Fauvism and Expressionism. Unfortunately the trends they began dissappeared during war-time when society required that art be functional and painters were discouraged from experimenting further. Wu Dayu came from that time and place and therefore the style he uses in Peking Opera represents an unrealized dream.

In Wu's work, we find a modern style of Chinese oil painting. Though originated in western thought, it possesses characteristics and expressions of its own, possibly making it more significant than western style in pure form. A principle of freehand brushwork in traditional Chinese painting emphasizes a condensation and deformation of objects allowing the artist to express his feeling as opposed to objective reality. This is very much like the ideas expressed in modern western art. As interpreted in Mao Lizi's introduction of his "self" (utilizing his initials in *Departure*) the language from the outside world therefore becomes a "reference" rather than a model to merely copy.

Wang Huaiqing, who comes from a middle gen-eration of painters, seems more conscientious of this blending of styles and ideas. He takes the creative spirit of painting freely and at will draws upon material from his own life and culture, combining the two. His impressions of ancient architecture and furniture as illustrated in his paintings *Unassembled, 1994* (page 102) and *Stage, 1995* (page 103) become unique under his brush!

Well into the decade of the 1990s, oil painting has been recognized as a compatible form of art to many others in China. But the borders are expanding. The artists are interested in continuing their experimentation. Photo Realism and Expressionism are often represented in the same exhibition and we no longer ask "Is Modernism needed?" but rather "How do we establish a school of Chinese Modernism?" Such questioning will enable Chinese oil painting to develop into the next decade as successfully as it has over the last as is demonstrated in the group of paintings that comprise the Hefner Collection.

(Fan Dian is an art critic, Associate Professor and Assistant President of the Central Academy of Fine Arts, Beijing. He is also a member of the Chinese Oil Painting Association.)

Collection

Ai Xuan

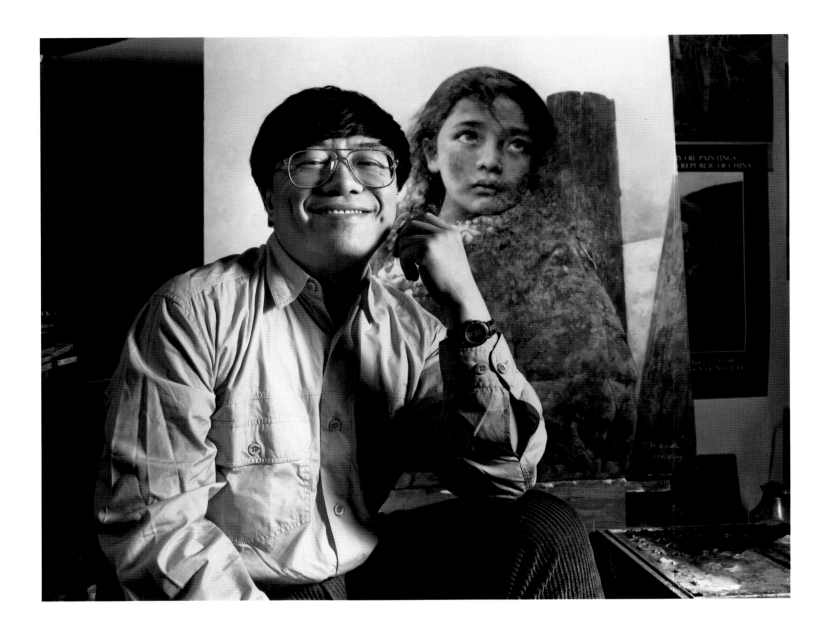

"I didn't deliberately create my style. It has been formed naturally over the years and represents a combination of many influences; American, Russian, European and Chinese. I like the American painter Andrew Wyeth and we met once and talked about our art. I felt we shared common emotions about loneliness and isolation and we agreed there's similarities in the way we use light. In my work, I attempt to express contradictory feelings about life and nature. There are people who have no control over their lives or where they live. They feel lonely and isolated like the figure in *February In An-Qu Village* or the young person who is the subject of *Winter Afternoon*. There was a time when I could identify with them and I've never forgotten it."

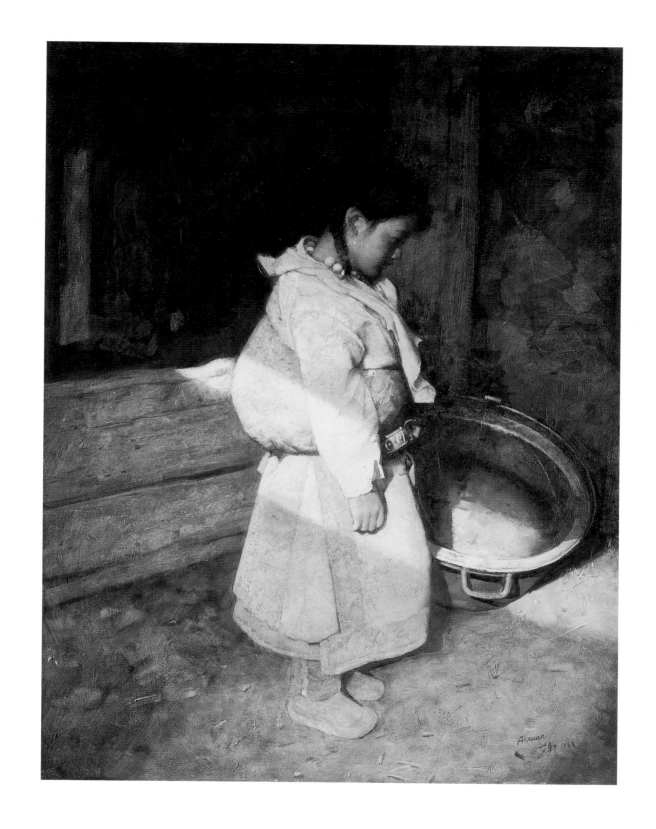

Winter Afternoon, 1988
Oil on Canvas, 34 x 33 inches

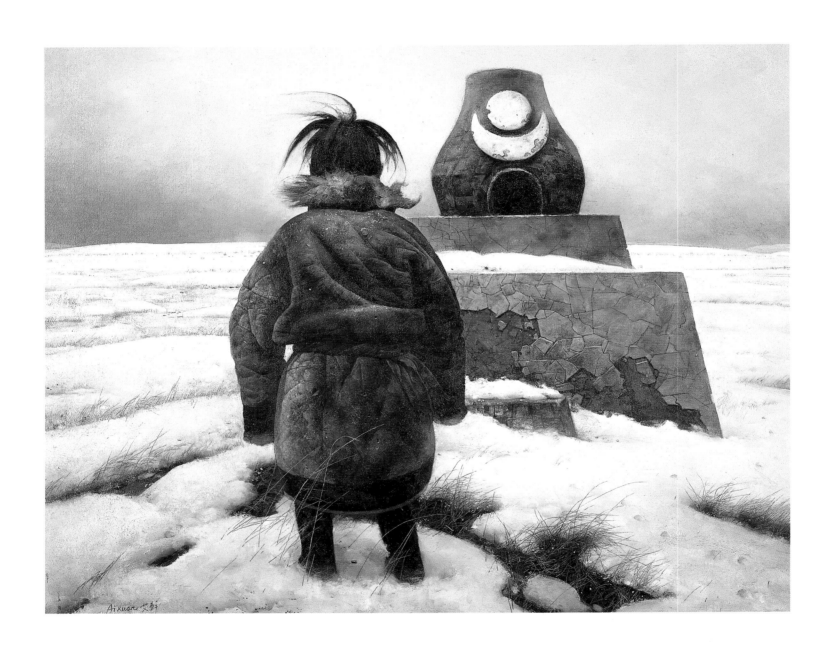

February In An-Qu Village, 1988

Oil on Canvas, 31 x 39 inches

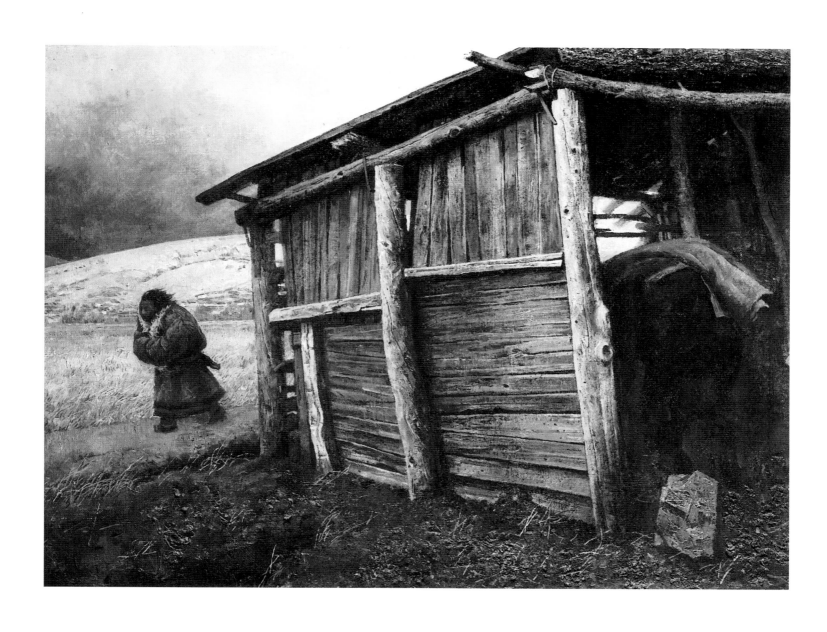

The Seasonal Wind at Nuo Ergai, Tibet, 1982

Oil on Board, 19 x 25 inches

Cai Jipin

In this trompe l'oeil piece, Cai Jipin has expertly reproduced a common cabinet found in his apartment which also serves as his studio. The tools of his profession; a slide projector, folded easel and stool, a roll of film and tubes of paint, share space with everyday household necessities; cooking utensils, vegetables and spices, a lock and set of keys and a small bottle of pills. The cabinet is actually made of two wooden boxes set end on end. A make-shift curtain presumably keeps dirt and dust from the food stored there. The painting, considered a still life by the artist was produced in 1987. Ten years earlier such a subject would have been considered frivolous.

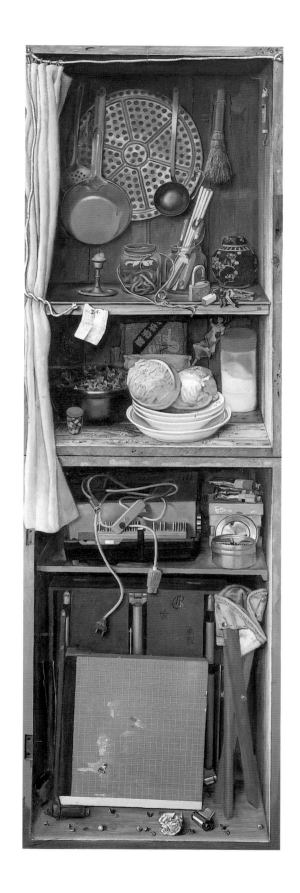

Still Life, Cabbage and Projector, 1987
Oil on Board, 70 x 22 x 2 inches

Cao Li

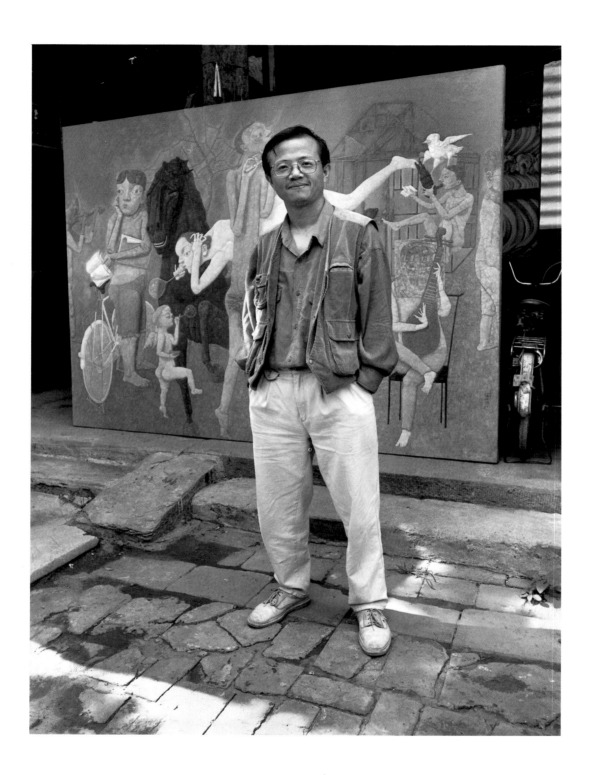

"My painting, like poetry, is a combination of imagination and reality. I feel sometimes that I am living in another world, a dream world that I inhabit in my waking hours and my paintings reflect that world. *Opened Notebook* is autobiographical and includes both my real world experiences and pieces of my dreams. I use the horse in my paintings to represent myself as I was born in the year of the horse."

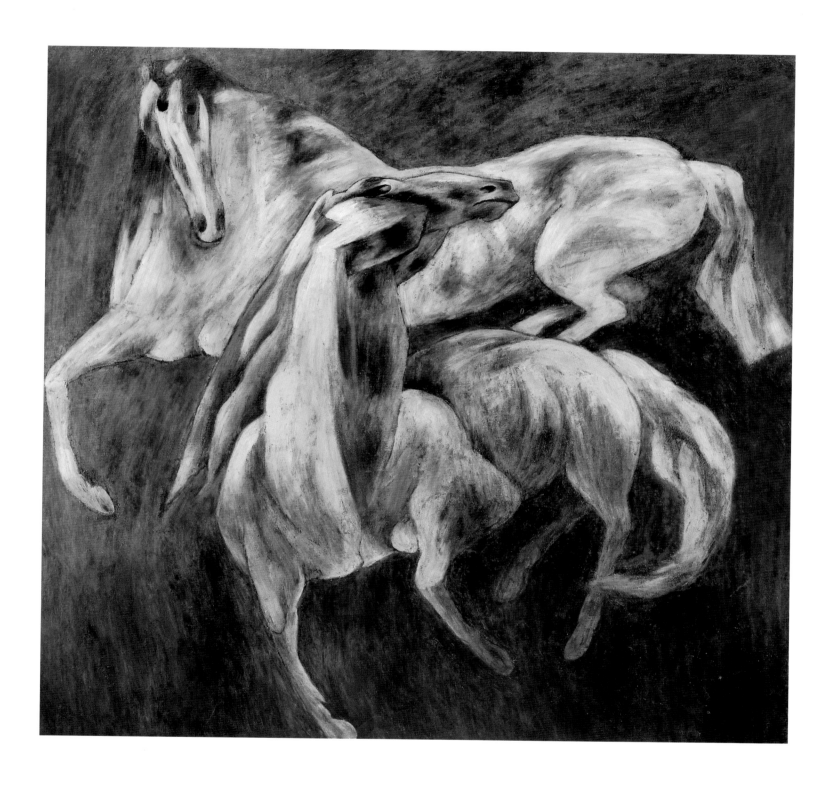

Horses, A Series, #7, 1986
Oil on Canvas, 61 x 64 inches

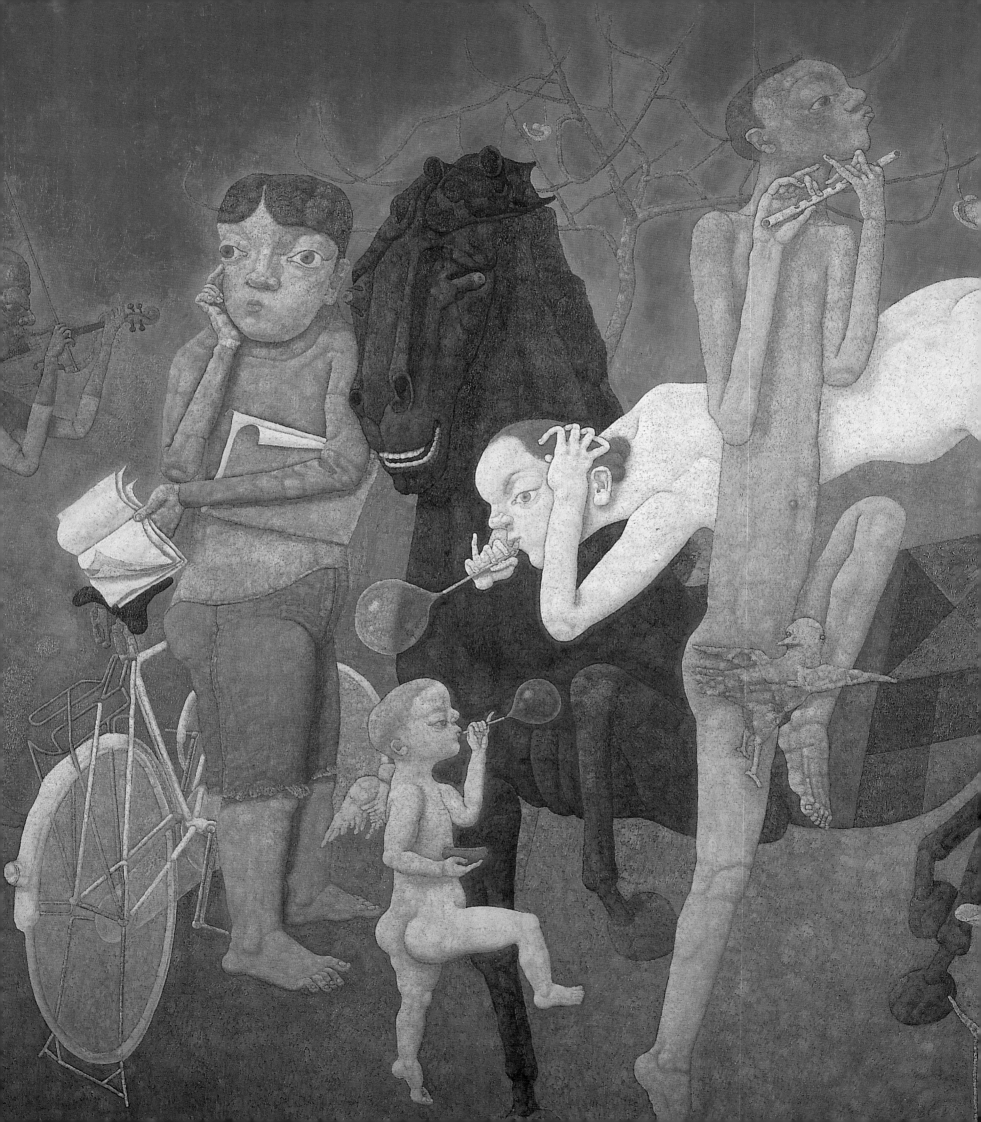

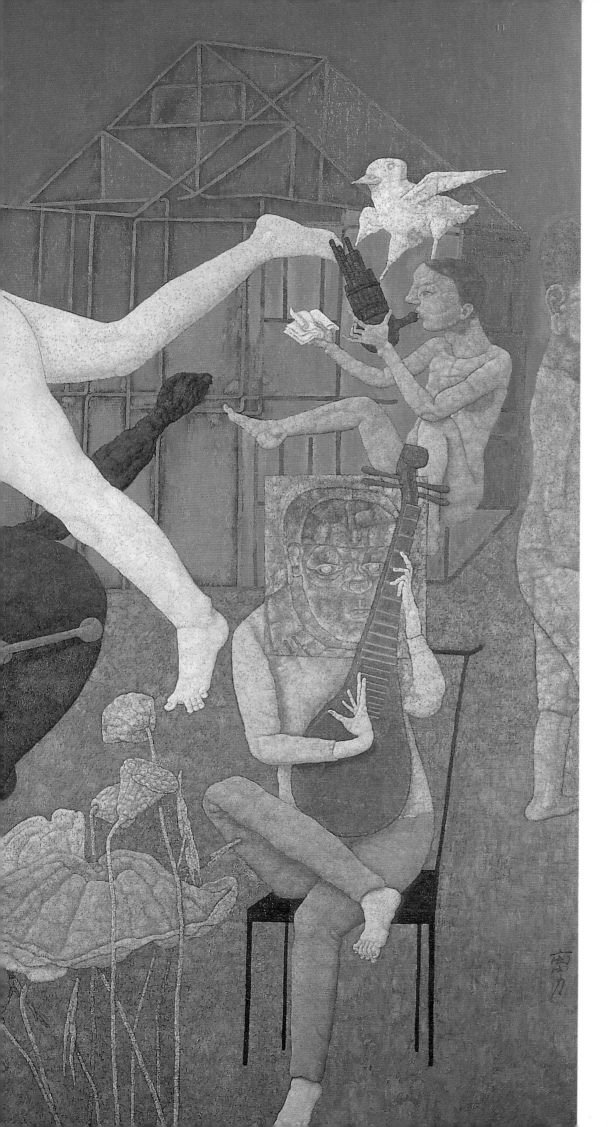

Opened Notebook, 1995
Oil on Canvas, 73 x 98 inches

"The painting, *The Last Song* represents a celebration of the China I knew, but is changing. At a typical Chinese funeral, the last song that is played or sung is always the best song. It celebrates the life of the deceased and it brings on happy memories."

The Last Song, 1996
Oil on Canvas, 72 x 102 inches

Cao Liwei

Cao Liwei has said that he came upon this minimalist scene while traveling on the Qinghai plateau. He has told colleagues that the simple structure of the house and the shadow cast upon it by a single tree left an indelible impression in his mind of this lonely landscape. He maintains that the deep blue of the sky was accurate and that it was not used to lend a surreal effect as many viewers have speculated. Critics have suggested that the composition can be interpreted as a dream landscape, typical of some of the most well-known works of classical Chinese brush painting. Whether or not it represents a comment on Western Surrealism, only the artist knows for sure. We do know however, that it is fairly atypical of many other landscape paintings he has produced in a Neo-Impressionist style.

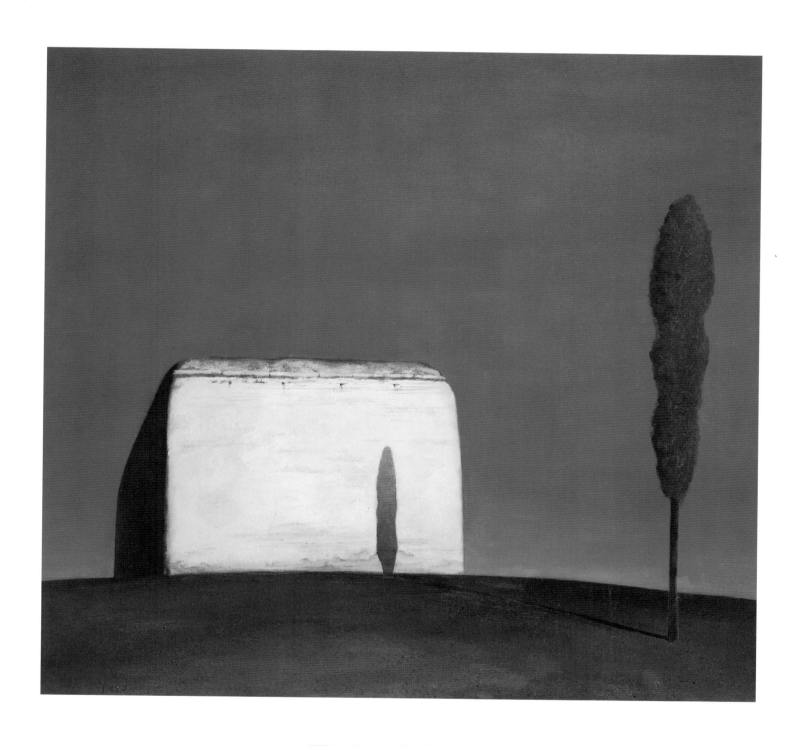

White House, Shadow of Tree, 1985
Oil on Canvas, 59 x 63 inches

Chang Qing

"I have always been interested in the still life. When I was a student, I studied the work of classical artists and I tried to copy it, but the painting *Bowl* represents a turning point in my work as it was the first time I felt I created something that was entirely my own. Besides the use of limited color, I like how the sharp, square edges of the table, the roundness of the bowl, and the shape of the doorknob all interact. There's no significance to the fact that I turned the bowl upside down, I just liked it better that way. If an artist is creative with the still life, it can be very exciting."

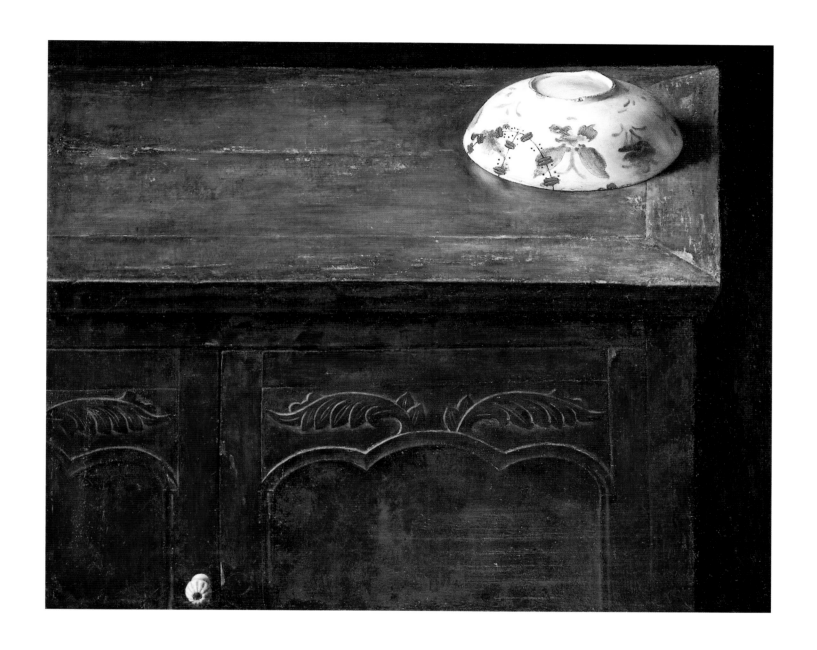

Bowl, 1987

Oil on Canvas, 15 x 19 inches

Chen Qiang

"I studied painting at the Central Academy in Beijing and I have traveled to many places in China, but as an artist I was never really influenced until I went to Tibet. There, I felt like I had returned home, like it was my spiritual home. The skys were so clear, life was so real and I felt this place deep inside of me so I began to paint what I saw like the *Horse and Rider* which was the first in a series of similar pieces stylistically. Although I no longer consider myself a painter – I'm now a performance artist and filmmaker – I still respond to Tibet and I still produce art that is influenced by my innermost feelings for that place."

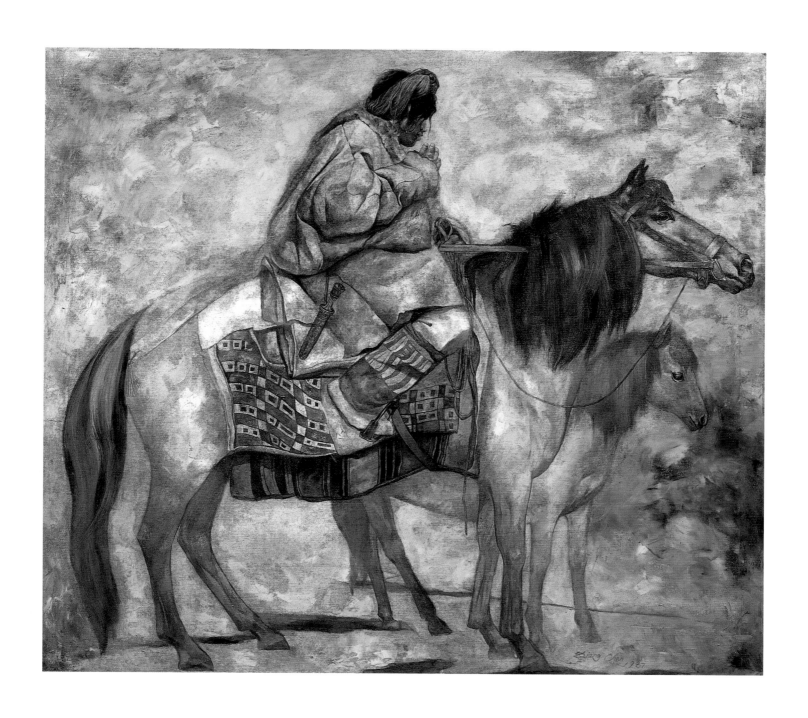

Horse and Rider, 1988
Oil on Canvas, 32 x 32 inches

Chen Yanning

Throughout most of his career, Chen Yanning has concentrated on the portrait, experimenting with a variety of styles and techniques. While *Winter Sunshine* illustrates a fairly typical scene, that of an old woman sitting halfway out of a door in the warmth of the light, it is the light itself that is the subject of the piece. The way it filters color, and shapes form in contrast challenges closer study. While the background at first appears black, it is actually full of color. In many of his paintings, Chen Yanning uses such nuance to draw the viewer into the work.

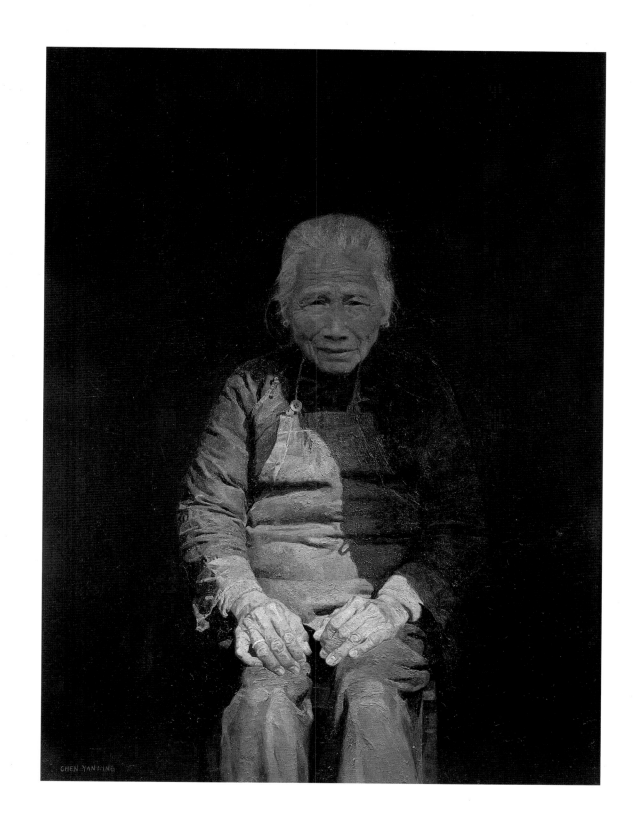

Winter Sunshine, 1988

Oil on Canvas, 40 x 30 inches

Robert A. Hefner III has acquired many Chen Yanning paintings since the two men first met in the early 1980s. In 1988, because of Hefner's pioneering work in natural gas, he commissioned the artist to travel to Sichuan Province where natural gas was first used, to research the origin of natural gas and drilling and its use, and paint a trilogy of works illustrating the three stages of natural gas development techniques in China. The resulting canvases became a part of the permanent contemporary Chinese oil painting collection and now hang in the Oklahoma City offices of Hefner's GHK Company.

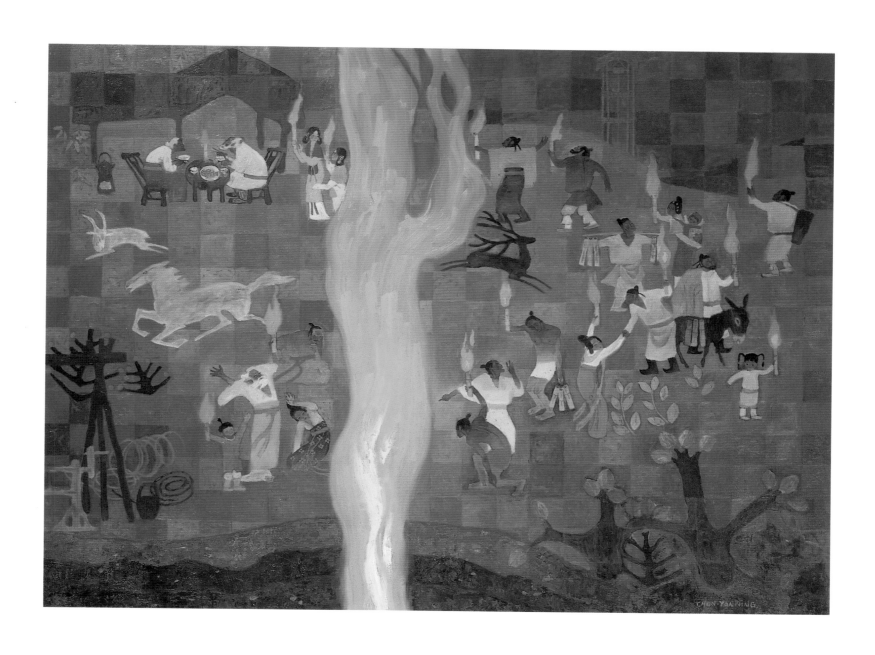

Early Natural Gas, circa 147 A.D. - 189 A.D.

Oil on Canvas, 36 x 48 inches, 1990

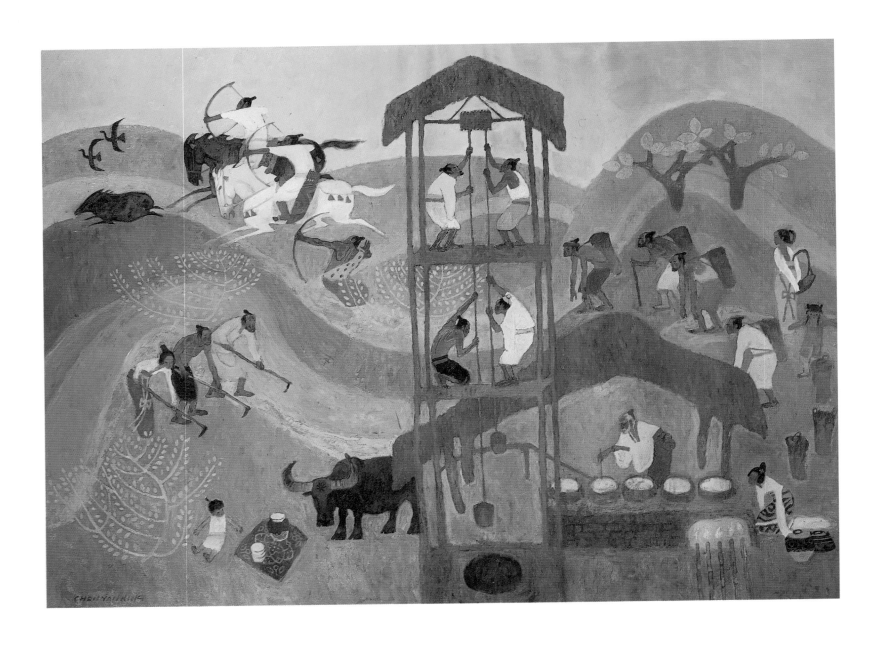

Early Natural Gas, circa 221 B.C. - 220 A.D.

Oil on Canvas, 36 x 48 inches, 1990

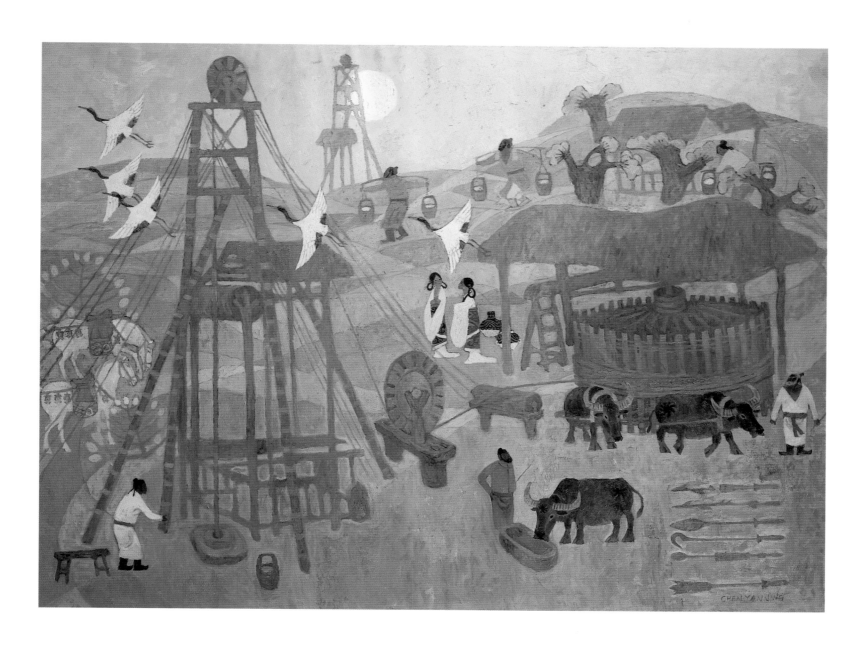

Early Natural Gas, circa 1041 A.D. - 1368 A.D.

Oil on Canvas, 36 x 48 inches, 1990

Chen Yifei

"It is important for an artist to understand his own culture. He may copy the work of another culture, but ultimately, the language of art is the language of one's own life. I have of course, always been attracted to the bridges, boats and canals of Suzhou that were a part of my life. No matter what else I paint, I will keep this subject close. I think of every piece I produce like a poem or a song for which there is an audience."

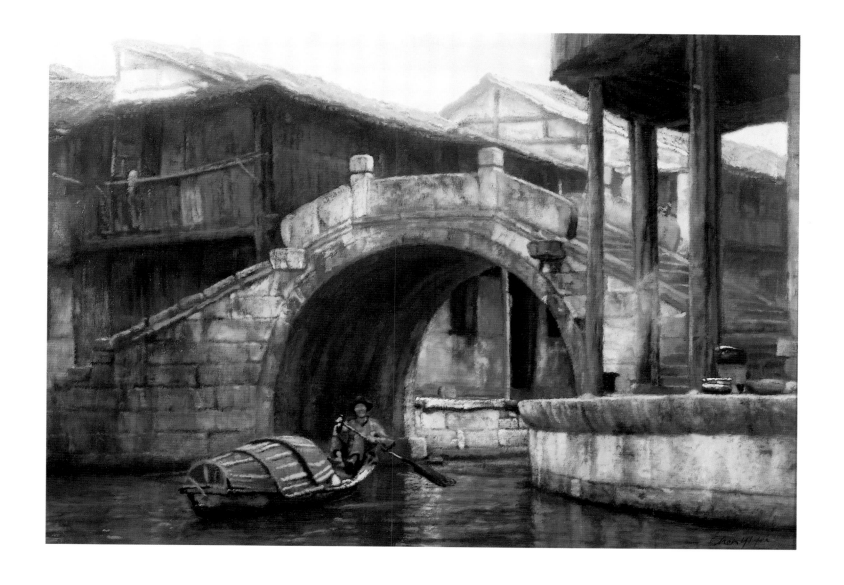

Return from Work, 1984

Oil on Canvas, 30 x 42 inches

Guo Chunming

The sense of isolation that is a part of life in a mountain village is conveyed by Guo Chunming in a straightforward, unemotional way although the title suggests that this scene may be from the Artists' own life experience. The power of the composition lies in the contrast it presents not only between the planes of light and shadow falling on earth and water, but in the obvious contrast between the size of the sole human figure – a young child – and the ox upon which she sits. The term Country Realism was created to define a genre Chinese oil painters of Guo's generation developed following the Cultural Revolution and it correctly applies to this work.

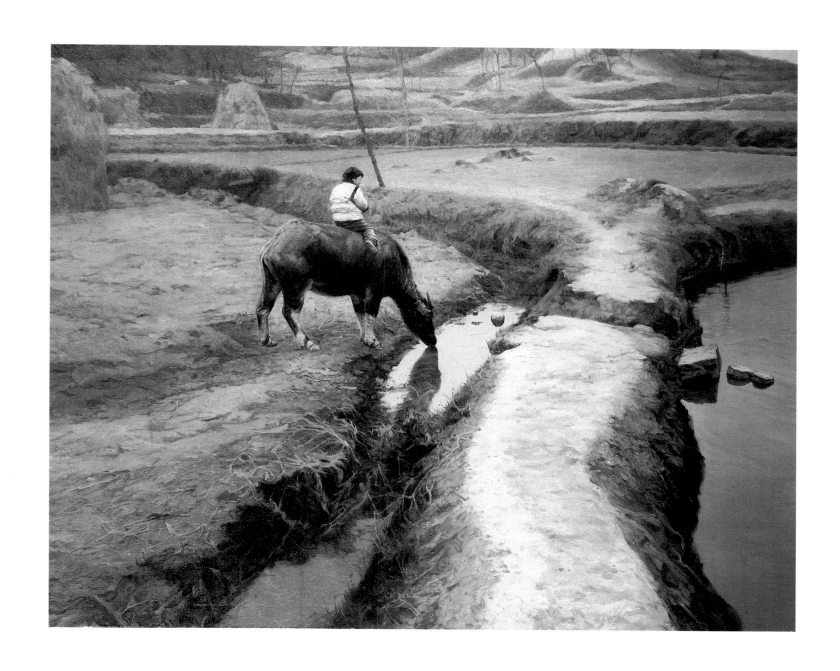

Reminiscences of the Mountain Village, 1987
Oil on Canvas, 45 x 55 inches

He Daqiao

"The painting *Still Life*, the one with the skull, was made in 1987 and won the Prize of Excellence that year at the National Exhibition of Chinese Oil Painting. For all of my work, I choose objects that reflect Chinese life on one level or another. My brother-in-law brought me the skull and I had collected the rest of the antiques hoping to do an arrangement like this one one day. The things I use in my paintings can be found in many Chinese homes and when I make these still lifes I feel that I am communicating something about our ancient culture."

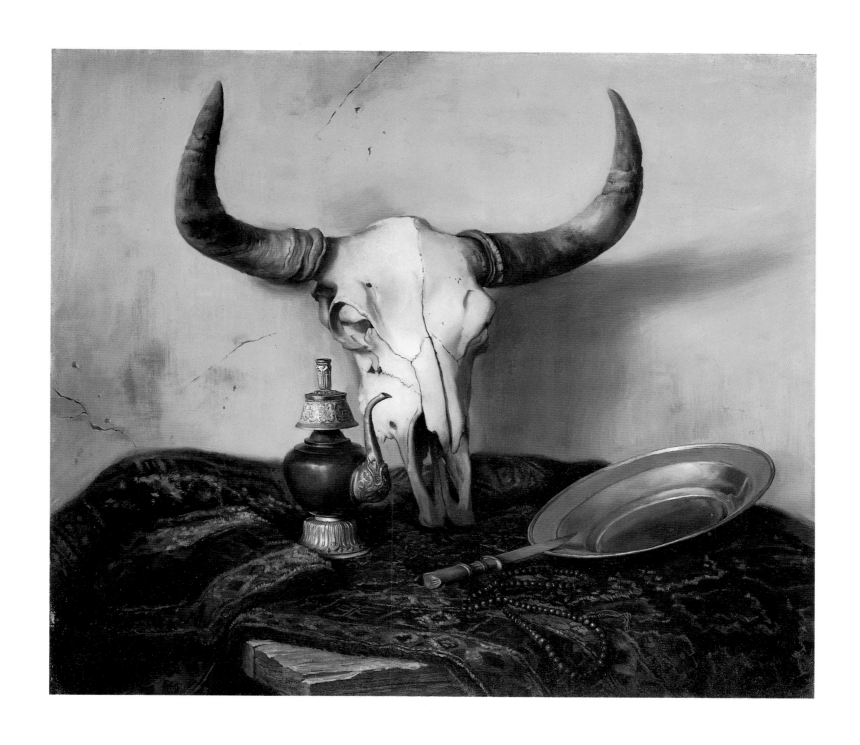

Still Life, 1987
Oil on Canvas, 28 x 31 inches

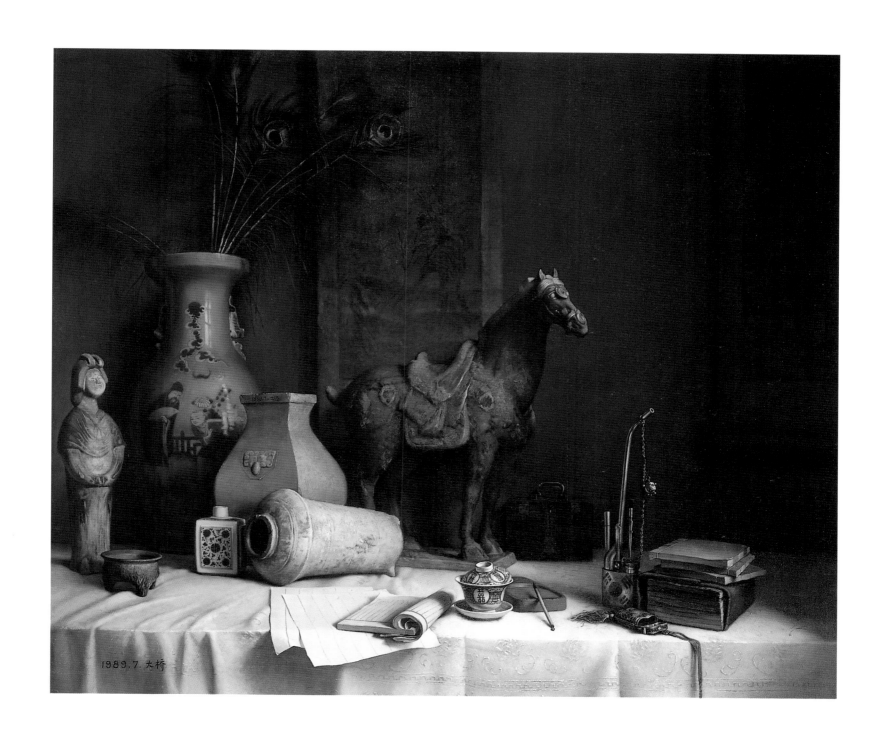

Untitled, 1989

Oil on Canvas, 48 x 56 inches

He Datian

In his *Doors and Windows* series that combines painting and scultpture in a unique presentation, He Datian lets the viewer see through the exterior window frames and into the courtyards of traditional southern Chinese homes. In this architecture, the roof and second story floor of the dwelling is supported by huge wooden beams or columns that either stand alone or are connected by plain whitewashed walls. Long corridors surround the courtyards that contain common kitchen or well areas and the only decorative touches are those of lattice-work added to the hand-carved wooden windows and doors.

These paintings are clearly about the dwellings themselves as the artist never includes signs of life. His sense of perspective and attention to detail however, draws the viewer into the works. The artist has said that the wooden shutters used here actually came from houses that were being renovated. Because such pieces of Chinese history and culture gradually disappear, art like He Datians' may become our only link to the past.

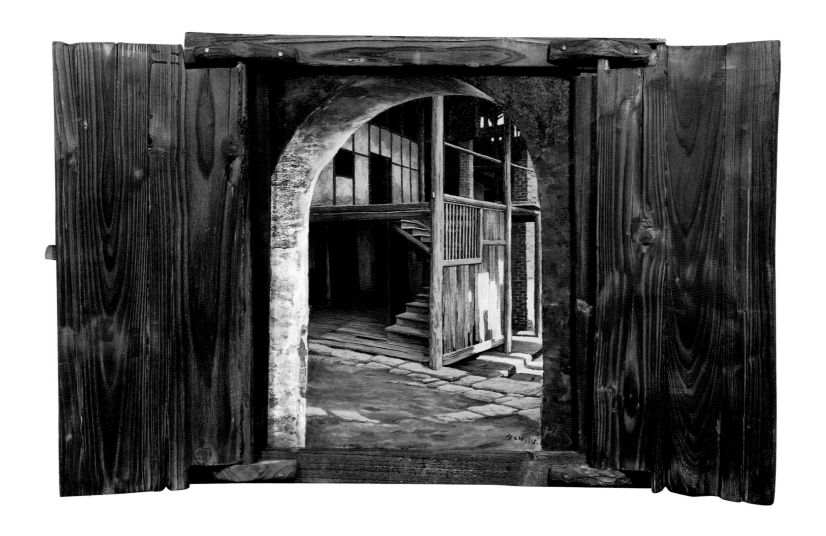

Old House, Setting Sun, 1988
Oil On Canvas with Carved Wood Window Frame
22 x 36 inches

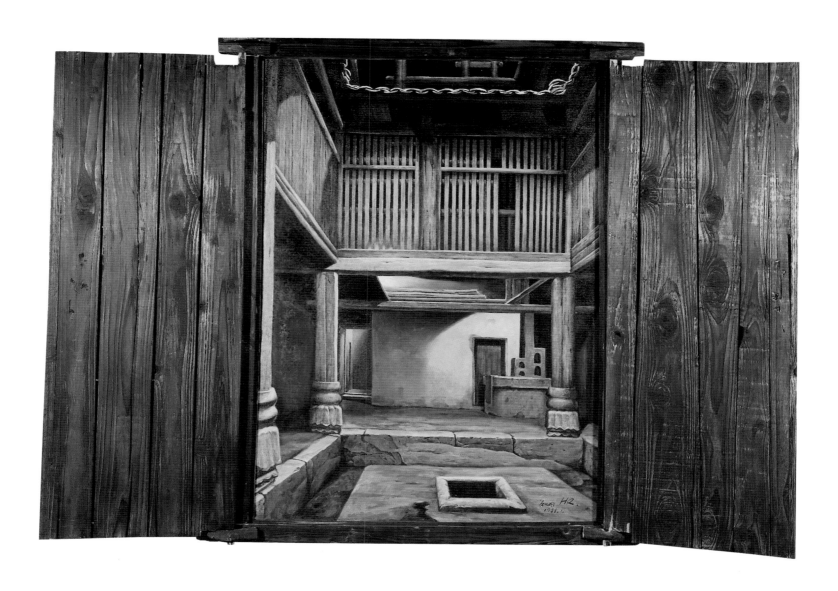

Old House, Kitchen, 1988

Oil on Canvas with Carved Wood Window Frame

36 x 90 1/2 inches

He Jiancheng

This painting is part of a series of works in which the artist has focused on the mysterious presence of monolithic stones found within the natural landscape. As if to suggest that this particular stone either draws from or emmits energy back to the surrounding earth, the viewer can sense movement in the tall grass, almost as though it is being pulled toward the stone. The blue-gray, atmospheric light adds to the implication that nature is the timeless, universal force within all things.

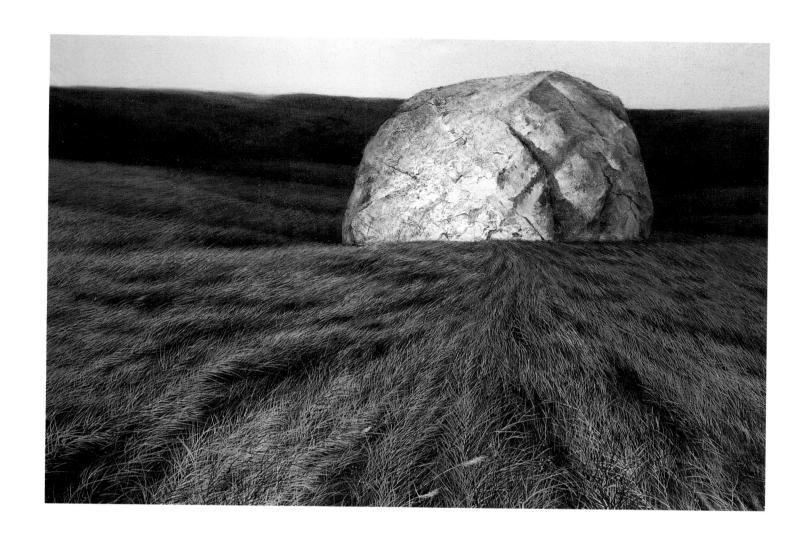

Original Shape #8, 1987
Oil on Canvas, 48 x 70 inches

He Kongde

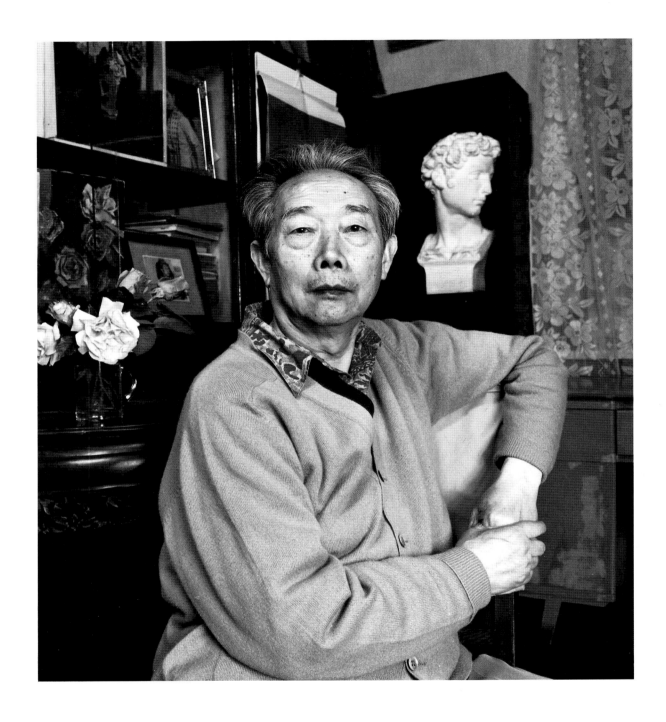

"I went away to the Korean War and when I returned, I was interested in painting subjects that dealt with that experience. When I did *Coming Out To Attack*, I was remembering being in a sort of mountain shelter while the Americans were bombing us. I could remember this scene exactly, and the soldiers in it, but somehow, I saw myself as the soldier in front so it became a self-portrait. I always admired the work of the Russian painter Nicolai Fechin and I think it influenced my style."

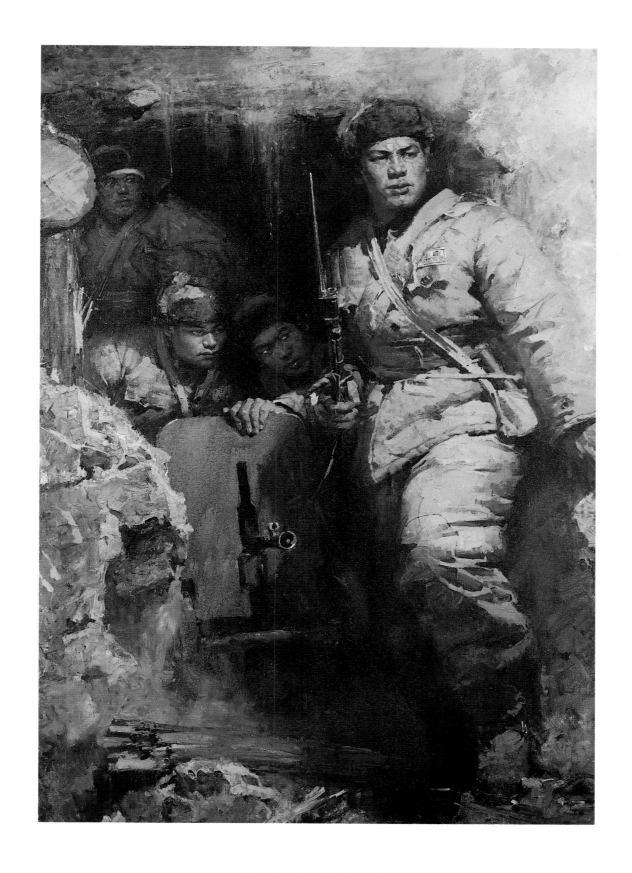

Coming Out To Attack, 1964

Oil on Canvas, 74 x 59 inches

Jian Feng

The Wish represents the beginning of the Hefner Collection as it was the first contemporary Chinese oil painting Robert A. Hefner III purchased in 1985. In this allegorical picture, a young Sichuanese man writes down information found on a wall poster that invites students to enroll for classes that prepare them for university entrance examinations. On the back of his bicycle are empty baskets, one holds a scale used for weighing out produce he has presumably sold at the free market. Tied to a back brace are textbooks he has possibly purchased with profits from his sales. The Chinese characters for the capital of Sichuan, painted in the top left corner are a tribute to Deng Xiaoping, also Sichuanese, who began his economic and political reforms in his home province giving hope to Chinese youth.

Such a poignant scene could not have been imagined prior to the end of the Cultural Revolution during which time the freedom to earn and the opportunity to study were repressed. Yet while this work was produced in 1984, overtones of the Socialist Realist style taught in Chinese art academies prior to the 1980s can be found in its' muted colors, atmospheric lighting and textural surface. This, added to the social statement it represents, makes it an important transitional piece in the collection as well as an important statement in the history of China.

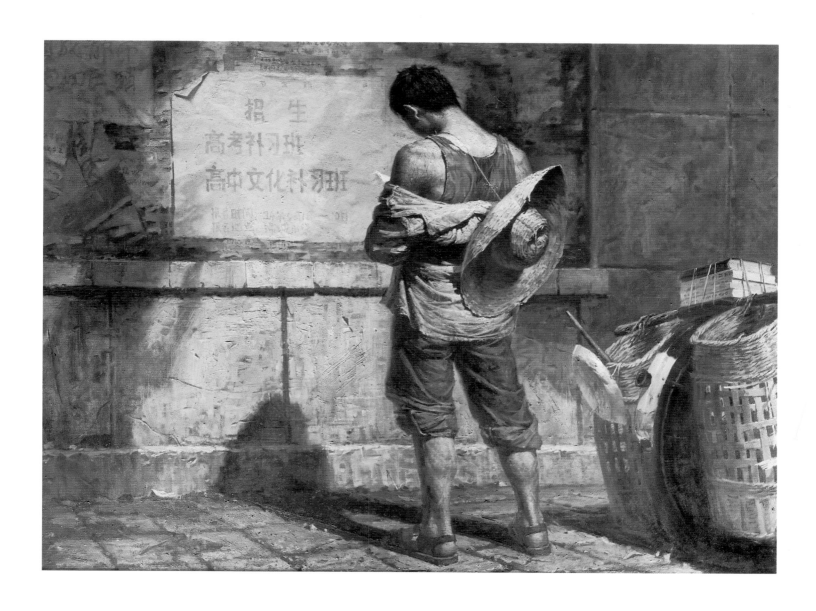

The Wish, 1984
Oil on Canvas, 49 x 65 inches

Kuang Jian

"I had long been curious about the minorities of the Pamir region in far Western China. I studied them in history books and when I was finally able to go there, I found these people very calm and friendly and I was attracted to them. I have used the young girl in *Sunshine of Pamir* in a few paintings. I especially liked her eyes; the way she seemed to look beyond any problems she might have. Her costume in this portrait is actually Han Chinese, not typically Pamir, but I liked the way she looked."

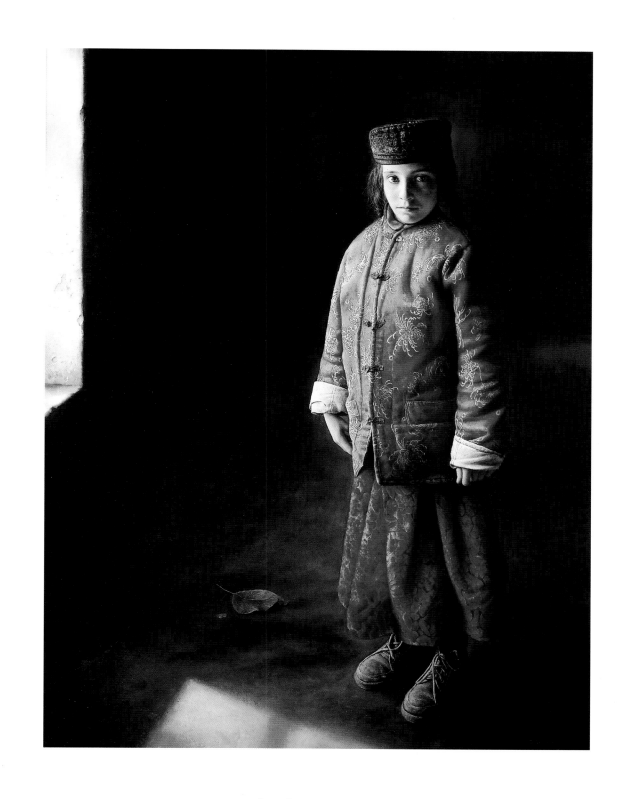

Sunshine of Pamir, 1994
Oil on Canvas, 57 x 44 inches

"In *Dislocation*, I am trying to express the reality of life in China today. For instance, economic reform in our country has affected different people in different ways and some don't know how to respond to it. They don't know which way they should go with their lives or the possibilities that are available to them so it's as if they are 'dislocated' in society. Everything in this painting is displaced; the girl is and isn't sitting in the chair, her boot is floating in mid-air, without any specific place to be. I painted this work in a super-realistic style, a little like Salvador Dali. The closer you look at the picture, the more you question it. The girl's feet are just a little too big, why does the paper cover her legs and so on. These are questions really."

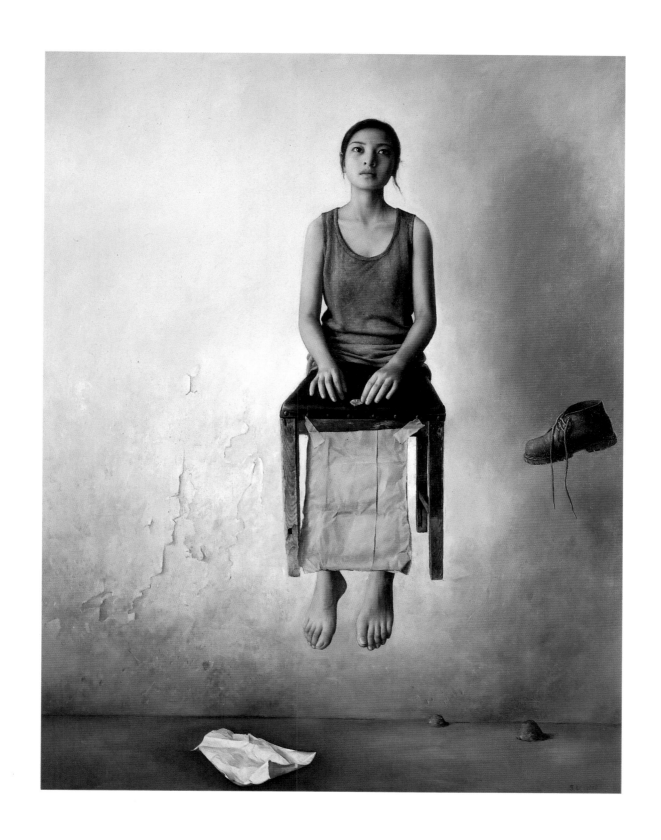

Dislocation, 1995

Oil on Canvas, 57 x 44 inches

Li Binggang

The transition from a Socialist Realist style, which was the only acceptable mode of painting in the 1960s and 1970s, to other forms of oil painting in contemporary Chinese art went quickly following the Cultural Revolution. However, in *People's Own Army*, produced in 1984, Li Binggang is still dependant on other ideologies. He shows us a soldier from the People's Liberation Army who pauses for a drink in the midst of debris left by an earthquake that leveled much of the city of Tianjian in 1976. This heroic picture honors the triumphs of the soldiers during that great tragedy. Typical of the Socialist Realist style previously practiced, it becomes an important transitional piece in the collection as well as an historical reference work.

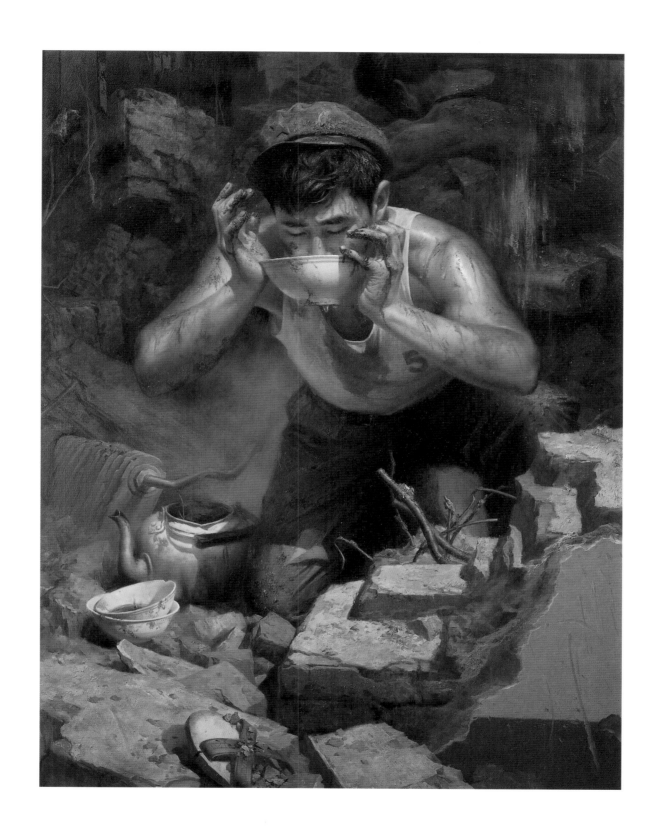

People's Own Army, 1984
Oil on Canvas, 67 x 52 inches

Li Kai

"I was an artist in residence at the Forbidden City for eight years. In 1974, during the Cultural Revolution, I was assigned a job there as a restorationist, cleaning and repairing paintings and other art within the Palace grounds. I lived in a small apartment that had existed for centuries and every day as I returned to it, I would pass by a gate and it somehow left a deep impression on me. When I made this painting, the gate was just as it is shown, worn by time and missing some of the large gold-plated nails. There are nearly 1000 doors or gates in the Forbidden City, but I think this one must be at least 500 years old and to me, it holds the entire history of the place."

Palace Door, 1986

Oil on Board, 39 x 31 inches

Li Xiushi

"In the 1960s, we were required to paint many portraits, but I liked landscapes. I was also criticized for not paying more attention to political matters. So, *Winding Through A Thousand Autumns* is, for the most part, a reaction to this. It's a picture of the Great Wall which represents all of the people of China but if you look carefully, in the stone you see the faces of many leaders in the Chinese Revolution and some from the Democratic party; Mao Zedong, Liu Shaoqi, Shundi, Zhou Enlai, Shu Yeshan, Shong Qinning, Liao Zhongkai, Feng Yuxiang, Lu Sun Qi Baishi and Zhang Zhixin. They represent the history of China and her struggles."

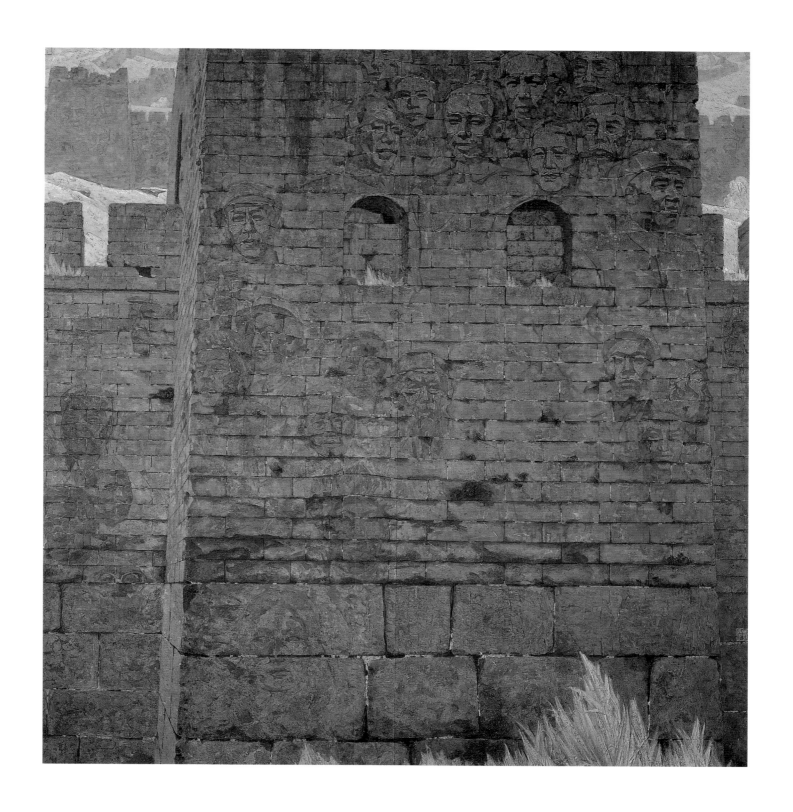

Winding Through a Thousand Autumns, 1984

Oil on Canvas, 80 x 76 inches

Lin Hongji

Lin Hongji has spent much of his adult life in Guangdong province in southeastern China. Given his interest in landscape painting, this semi-tropical coastal area, full of inlets and waterways, provided the artist with many subjects. In *Boat Carrying Grass*, he has used a style reminiscent of the Barbizon school. The soft, impressionistic brush strokes, twilight illumination and peaceful composition, suggests a life in this region that is far removed from the bustle of the cities. Many critics of the period of oil painting immediately following the Cultural Revolution have suggested the painters needed to return to beauty in art and one way was to search for a quality of life found in nature.

Boat Carrying Grass, 1987

Oil on Canvas, 30 x 40 inches

Lui Aimen

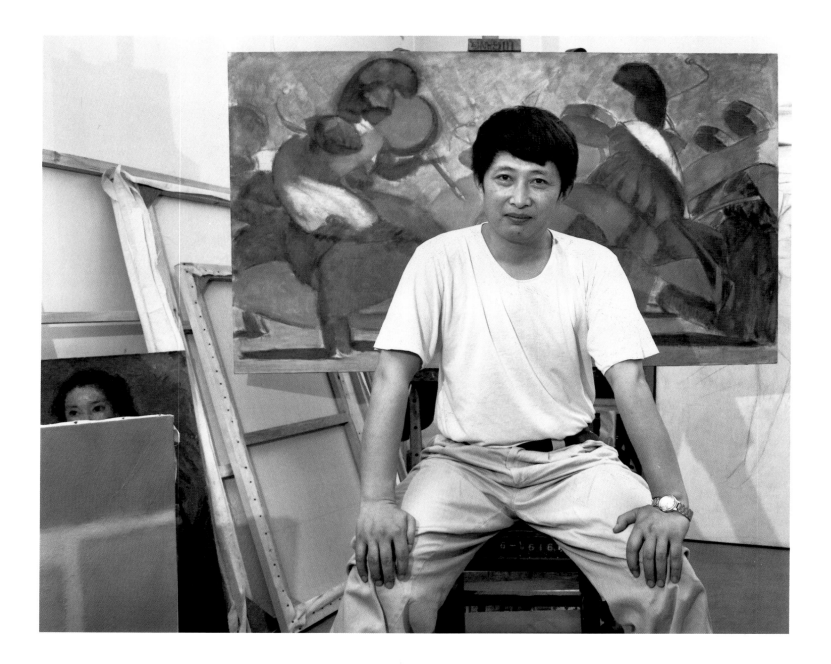

"At the beginning of my career, I was required to do propagada paintings and then murals of political subjects. *Sisters* was one of the first paintings I made after the Cultural Revolution that I considered personal. I felt so released and free when I completed it. The subjects are sisters who get up very early in the morning to carry their vegetables from the country into town to sell. They work all day on the streets and then go home after dark. Here they are so tired, they have stopped to sleep by the side of the road. I would consider the style to be Romantic Realism."

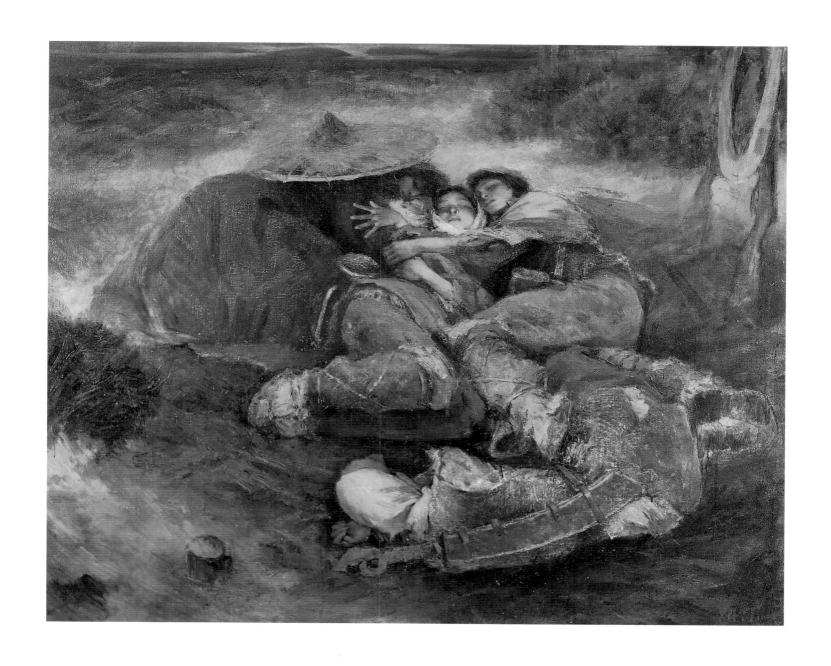

Sisters, 1984

Oil on Canvas, 51 x 63 inches

Luo Erchun

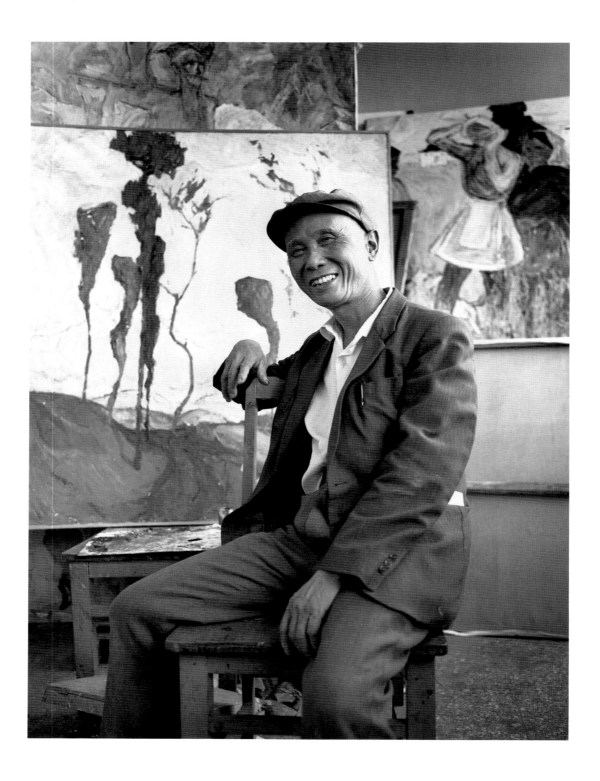

"I was born in 1930 in Hunan province and even though I've lived most of my life in Beijing and sometimes in Paris, I still prefer to paint scenes from my homeland. I feel a passion for this. I am particularly interested in the color of the soil there which I still remember from my childhood. My painting, *The Hill* is full of the colors of the Hunan landscape. *Festival* is comprised of many faces and figure studies I did when I attended a minority festival in southern Hunan. I sketched the subjects and later put them altogether in my studio."

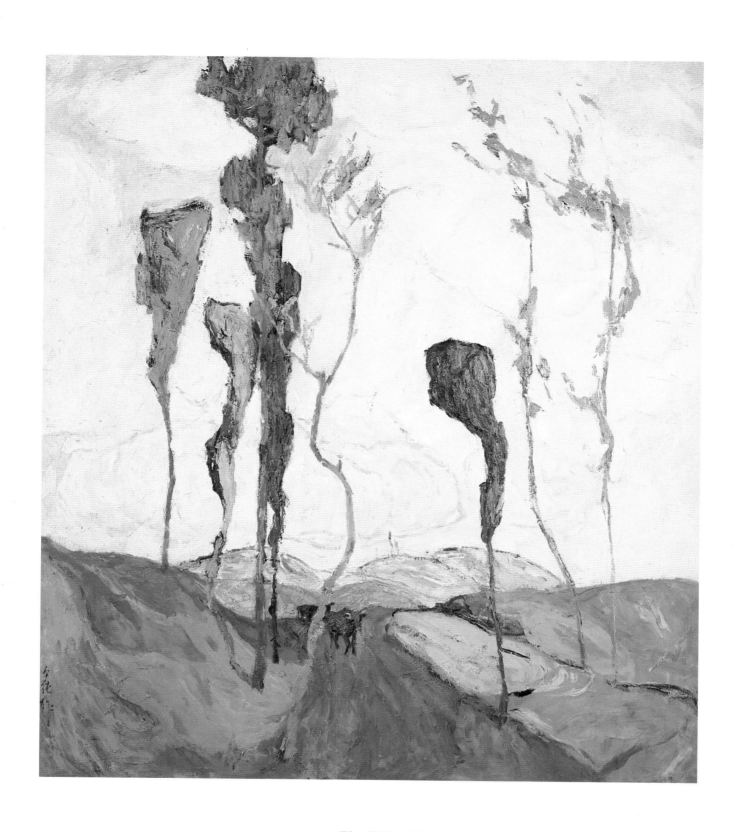

The Hill, 1985
Oil on Canvas, 51 x 45 inches

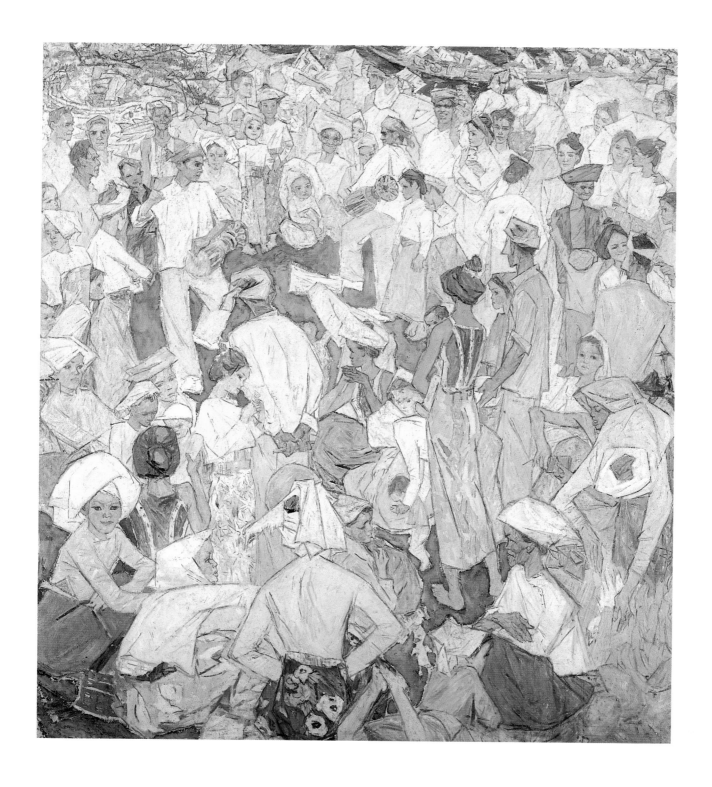

Festival, 1978

Oil on Canvas, 72 x 63 inches

Luo Zhongli

"The reason I choose to paint peasants as my main subjects is because my family was from the country, I grew up there and these are the people I know. During the Cultural Revolution I was required to paint a lot of political pictures in a large, heroic size including many portraits of Mao Tse-tung. Just after the Cultural Revolution, in 1980, I did a painting entitled *Father* which is really a summation of how I felt about my peasant subjects. Three years later I made *Father II*".

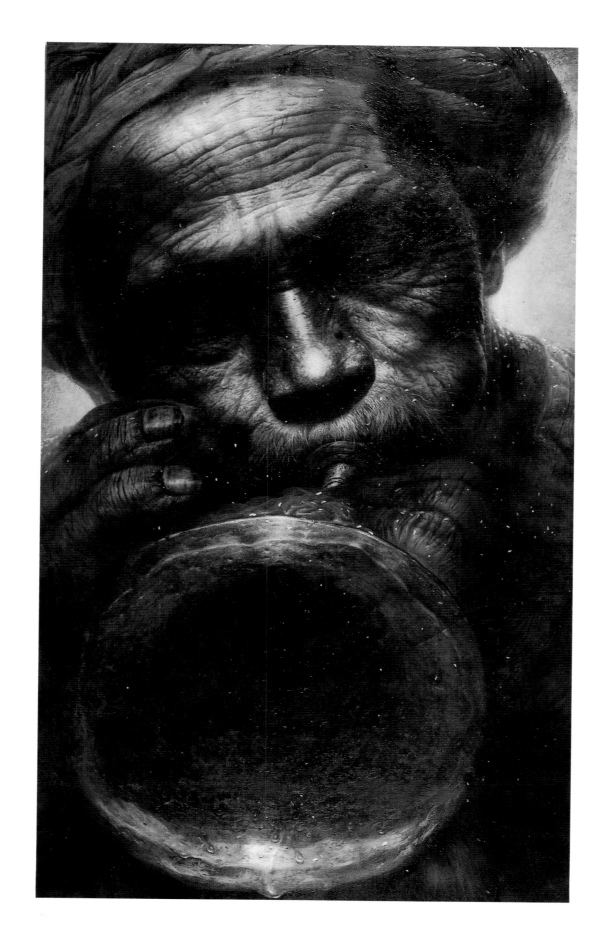

Father II, 1982
Oil on Canvas, 105 x 64 inches

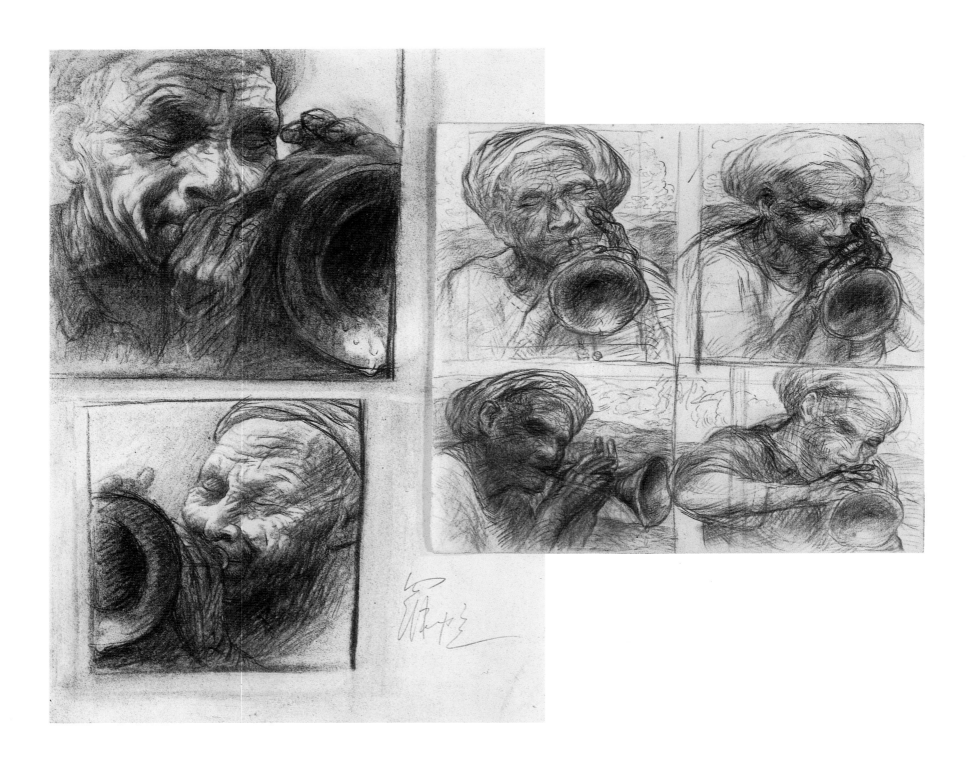

"I produced *Father* and *Father II* along with *Spring Silkworms*, in this size like the ones I had once been required to paint of Chairman Mao. I knew I had never seen paintings this large of peasants or farmers, but I honestly had no idea they would cause a sensation when exhibited. Technically, they are different from the Mao paintings. I borrowed the style from something I saw in a magazine by the American Photo Realist painter Chuck Close. The figure in *Father II* is inspired by several preliminary sketches I made of peasants at a country festival."

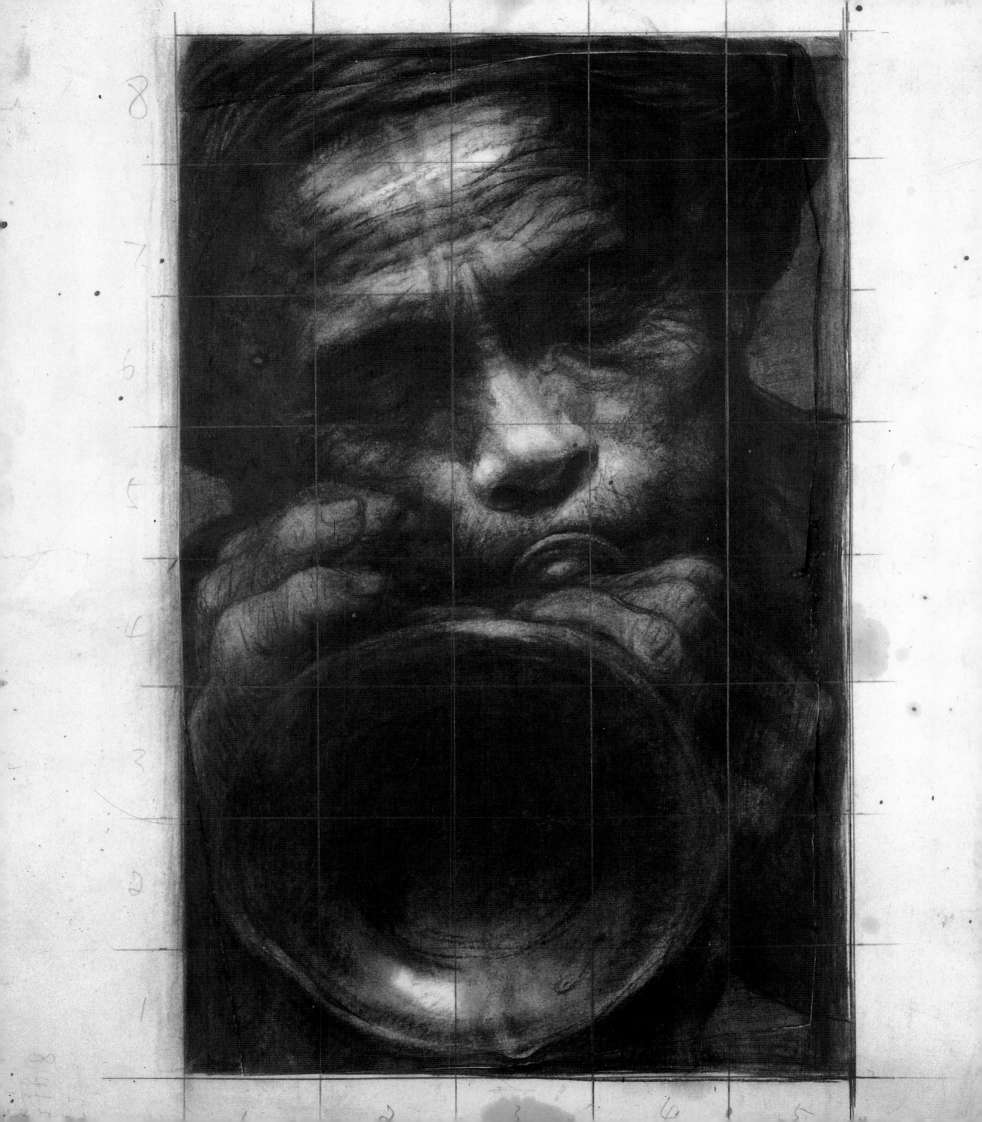

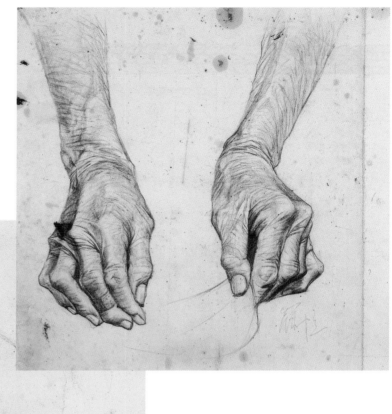

Detail, *Spring Silkworms*

Preliminary sketches, *Spring Silkworms*

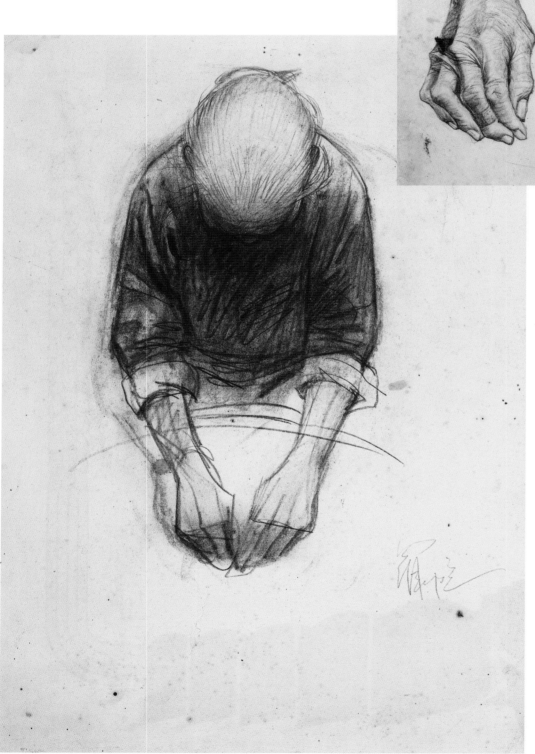

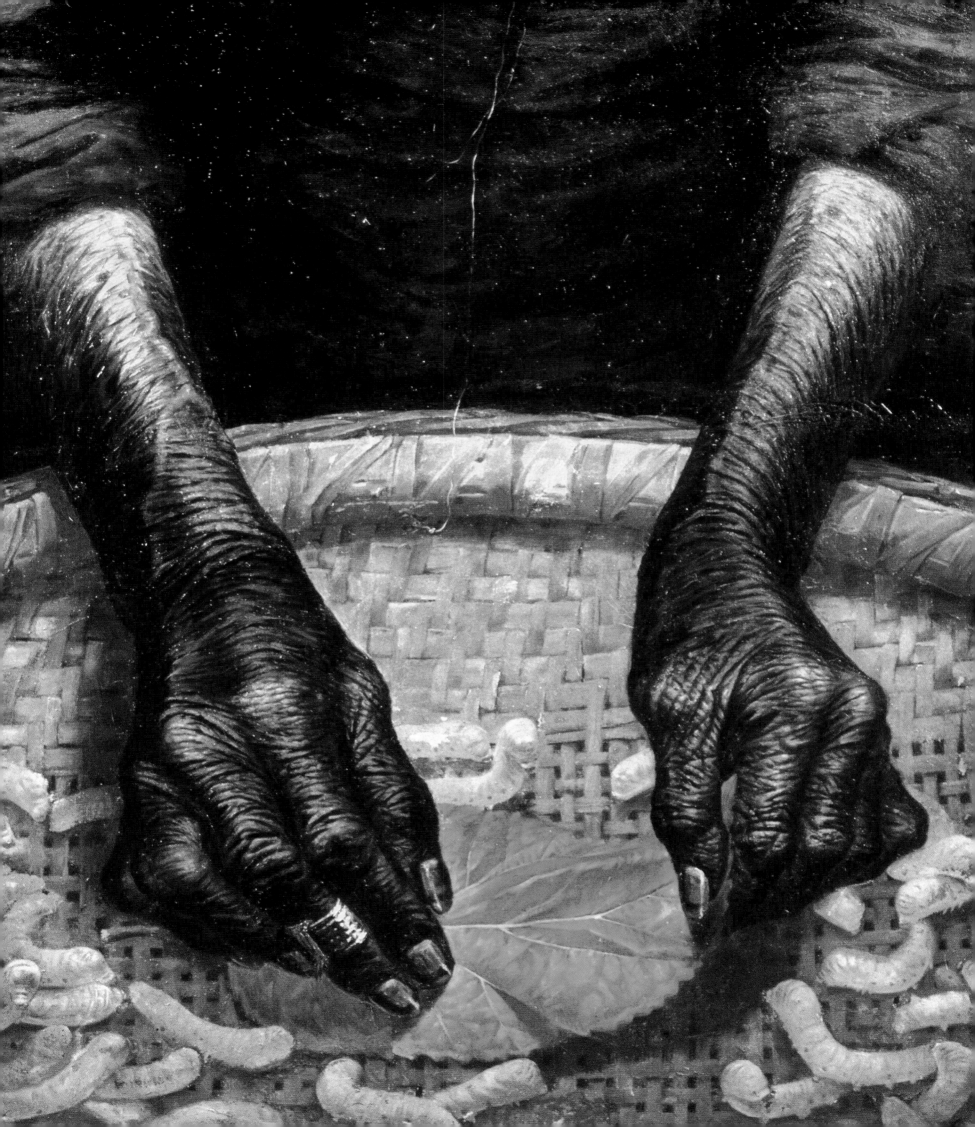

"*Spring Silkworms* came right after *Father* and was part of a series of only three pieces I ever painted this large. I was very close to the subject as I had worked on a silkworm farm. When I was young, I read a poem that said, like a candle that burns bright until it is burned up, the silkworm never dies until the last of its silk is given out, so I used a symbolic language in creating this piece. The Grandmother's hair resembles the silk she is harvesting. Like the worm itself, she will work all her life until she can work no more and then she will die. *Father II* is an old farmer who has worked equally long at the harvest and finally blows his horn, but with mixed emotions. To me, these paintings express the hard life of the Chinese peasants. I am glad they are a part of the same collection because they are so closely related they should not be separated."

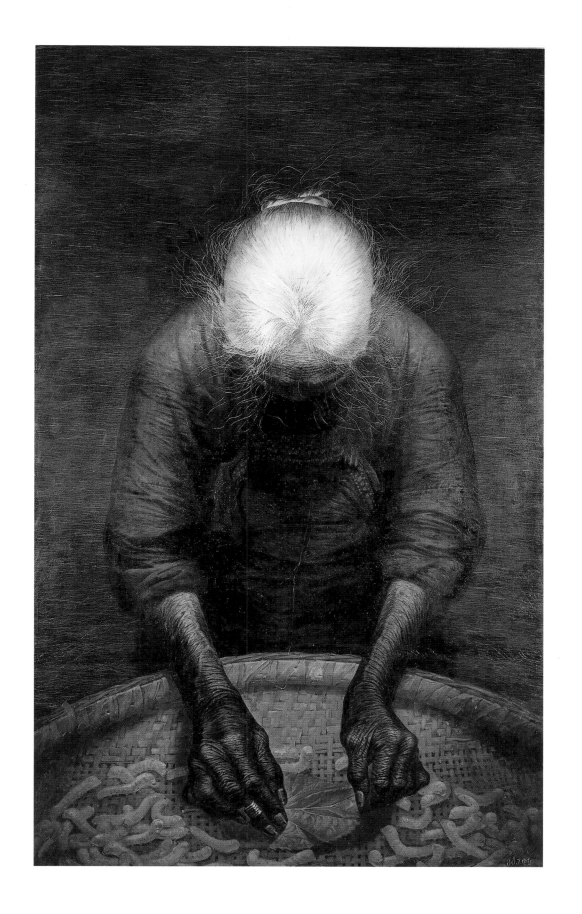

Spring Silkworms, 1980

Oil on Canvas, 93 x 56 inches

Mao Lizi

"I can't compare my paintings to others by contemporary Chinese artists and I don't think I've been influenced by any particular Western style either. I would describe what I do as Popular art. That doesn't mean Pop art and I don't use Photorealist techniques. I want my paintings to look exactly like what they are, so if I show graffiti or torn paper on a wall, it has to be the same size as the wall I remembered. Sometimes however, I add things that aren't there, that couldn't be there, to make those who see my paintings think in new ways."

Ancient China, 1986
Oil on Board, 26 x 26 inches

Departure, 1988

Oil on Board, 26 x 34 inches

Wang Huaiqing

"All of my work from early pieces like *Bo Le, A Man Who Knew Horses* to one of the most recent paintings, *Stage* has to do with Chinese culture and philosophy. *Bo Le* was a painting I made as a requirement for graduation from the Central Institute of Arts and was inspired by a Chinese folktale. I began the series on architecture and furniture when I went to a conference in Shaoxing in southern China and admired the houses there."

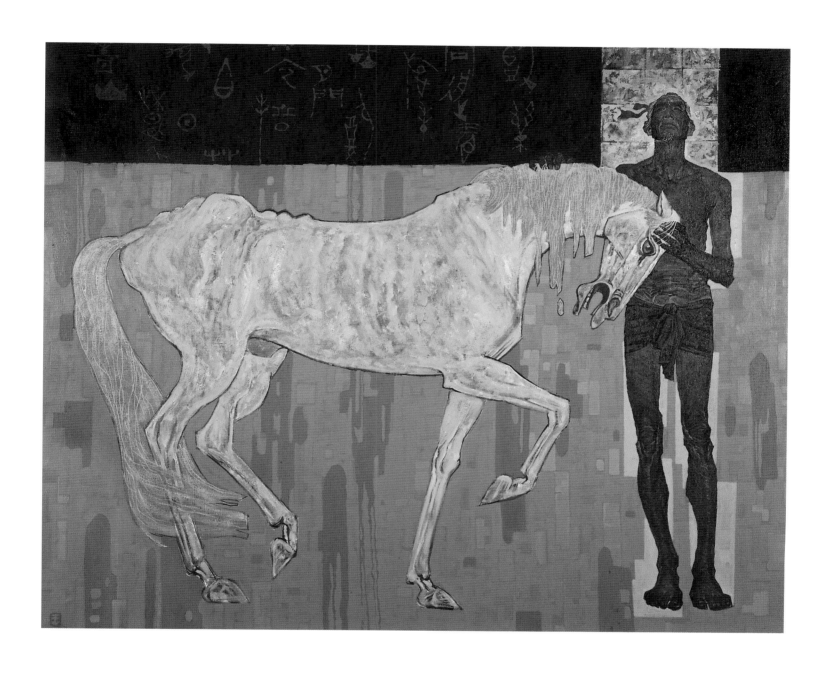

Bo Le, A Man Who Knew Horses, 1980
Oil on Canvas, 67 x 81 inches

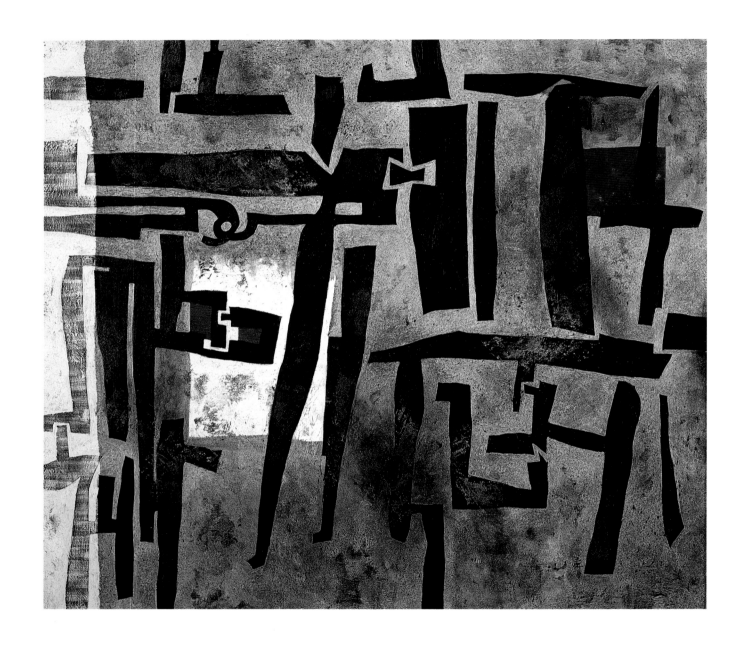

Unassembled, 1994

Oil on Canvas, 51 x 57 inches

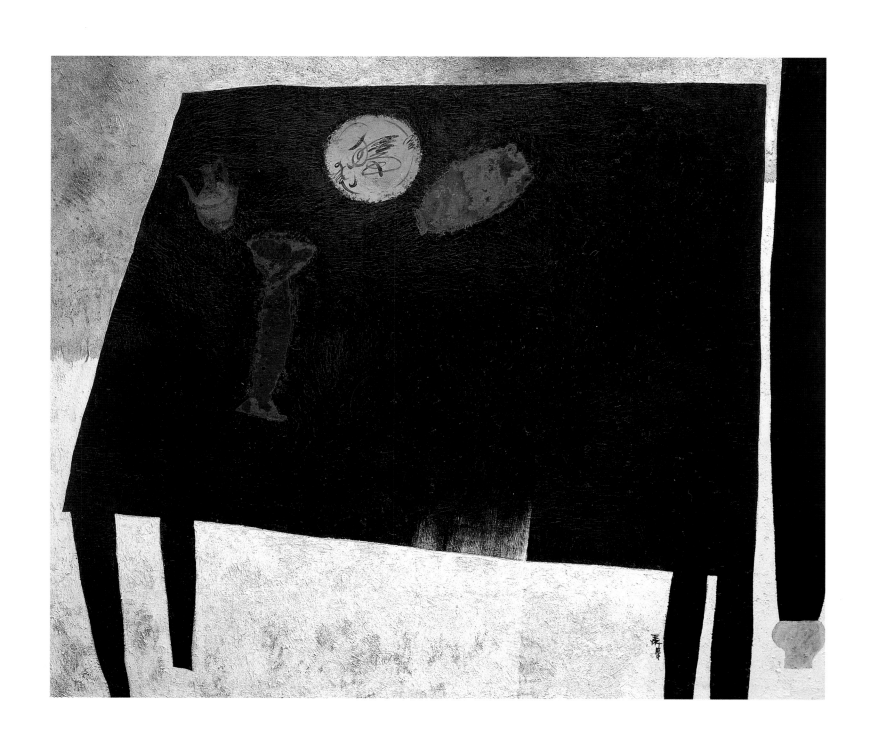

Stage, 1995
Oil on Canvas, 68 x 78 inches

"The ongoing series on classic Chinese architecture and furniture is abstract in many respects. The painting titled *Unassembled* shows a Ming chair from a different viewpoint, as if it had been exploded so that you could see all of its pieces. Normally, I use limited colors, mostly blacks and whites, but I added the red and green in this picture simply for contrast. It sets this painting apart from others in the series."

"*Stage* combines antiques from different dynasties on a table that is no longer a table. The objects upon it are seen from varied perspectives, but the vase is no longer a vase, the pot, not exactly a pot. It represents a new concept, for the objects and the painting as well. This series reflects my desire to maintain a connection to my heritage while making a philosophical statement about painting."

"*Artist's Mother* was made as a tribute to my neighbor, Zhou Huaiming who was a well known ink and brush painter. The subject was his mother, and she was 90 years old. The message of the painting is very Oriental and the perspective like that of traditional Chinese painting where you can see a subject from different levels and planes at the same time. I see a connection between all of my work produced over the last ten years, from *Bo Le, A Man Who Knew Horses*, to *Artists' Mother* and into the furniture series. If you look closely, there are common elements in all of these paintings."

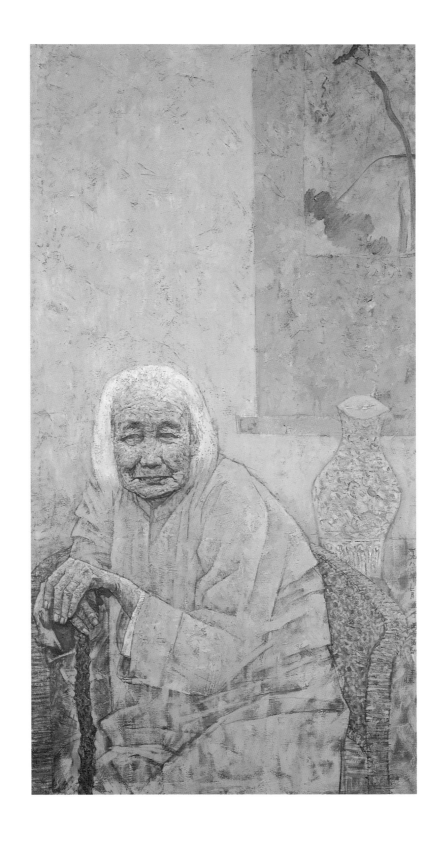

Artist's Mother, 1985
Oil on Canvas, 51 x 26 inches

Wang Yidong

"*South China Woman* is a portrait I made trying to combine an ancient Chinese style called Fantasy which is very precise and the early Renaissance style of painting. I found the model while traveling in Southern China. The two profiles, of men were done as demonstrations for my art students during a trip to the countryside. It took me a full day to finish each of these paintings, but I was very happy thinking about how I wanted to use Rembrandt's technique and use of light."

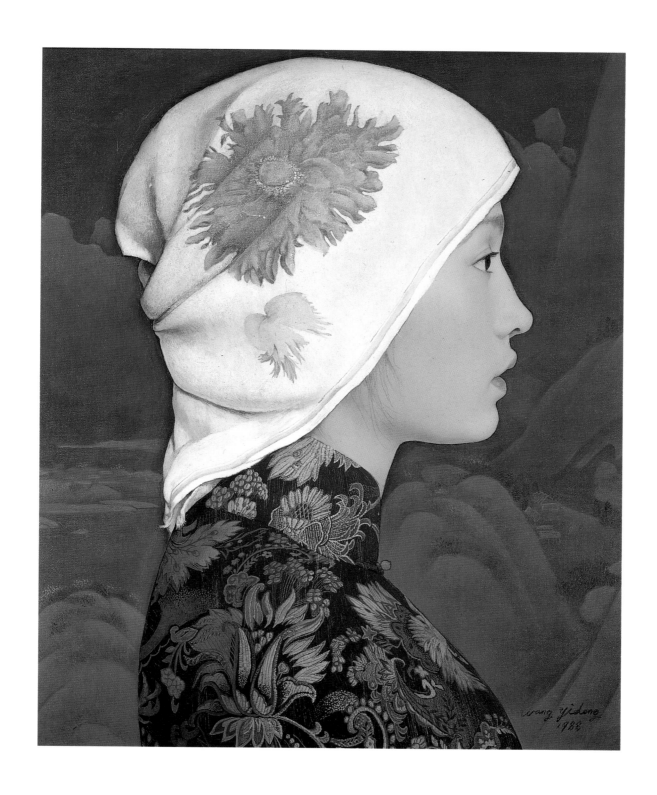

South China Woman, 1988

Oil on Canvas, 24 x 20 inches

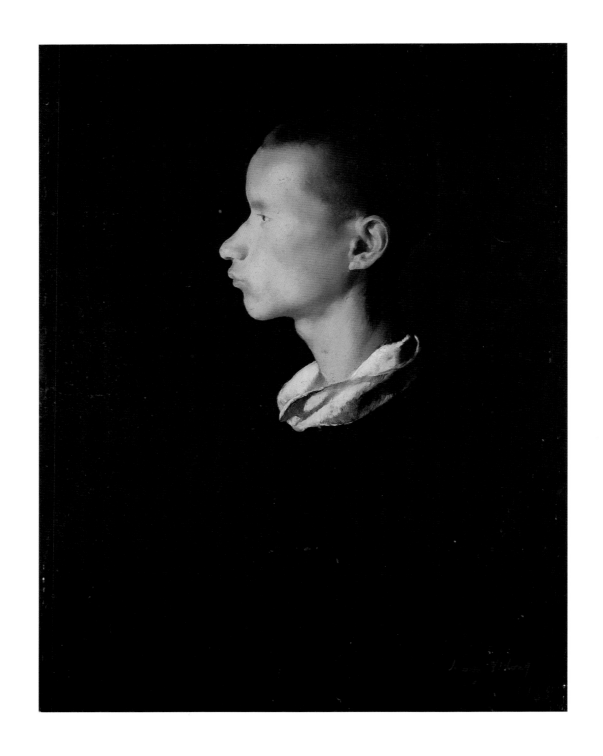

Profile of Young Man, 1986

Oil on Canvas, 23 x 19 inches

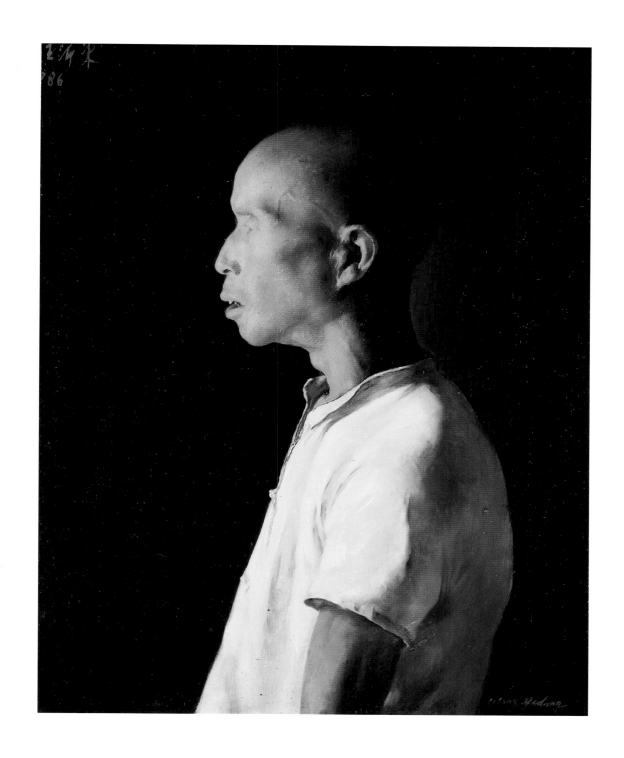

Profile of Old Man, 1986

Oil on Canvas, 23 x 18 inches

Wu Dayu

Wu Dayu was sent to Paris to study in the 1920s with the idea that he would return and teach European oil painting techniques in the Chinese academies. Subsequently, he was among the first generation of painters to introduce Post-Impressionism to his country. During the Cultural Revolution however, his teachings were denounced and all but a few of his works were destroyed. *Peking Opera* is one of the Artists' experimental pieces that survived.

Drawing obvious influence from the style of Cubism which he would have seen first-hand while studying in France, Wu fragments a colorful and energetic scene from a Chinese opera. The softening of brushstrokes that appear more spontaneous than studied and the rounding of shapes and planes, as opposed to the angularity normally found in Cubist works, add a unique Chinese feeling to the piece. *Peking Opera* is representative of how art develops through a blending of cultures.

Peking Opera, date unknown
Oil on Canvas, 21 1/2 x 15 inches

Wu Guanzhong

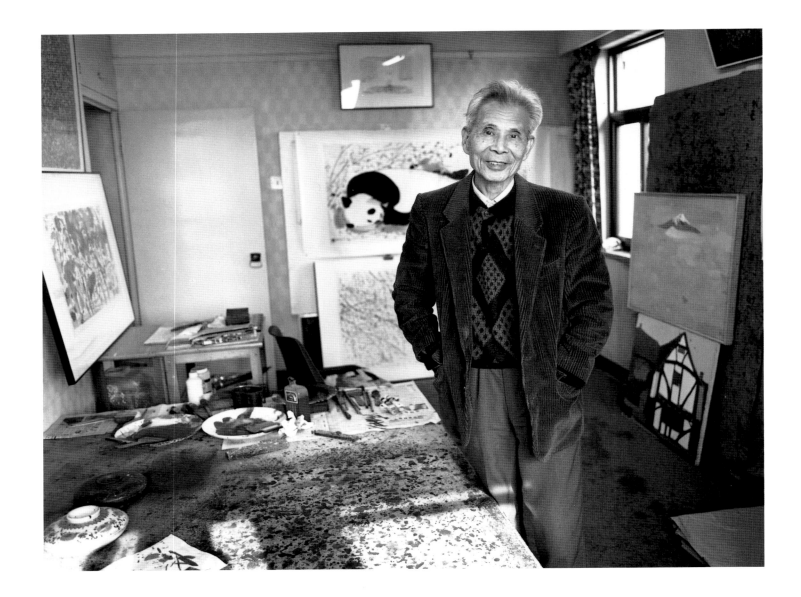

"Throughout my career, I have gone back and forth between brush painting and oil painting because I found that each technique has limitations. I have tried to combine them to develop my own style because I don't care about being a part of any one group or school of thought. As an artist you should be true to yourself. I have adopted Western oil painting techniques and applied them to traditional Chinese subjects. Some would say that we have to learn more from the West because there is no place else for us to go, we have to look for new forms of painting. But I believe the Chinese can create their own history and traditions in art and I believe history will put my contributions in the right place."

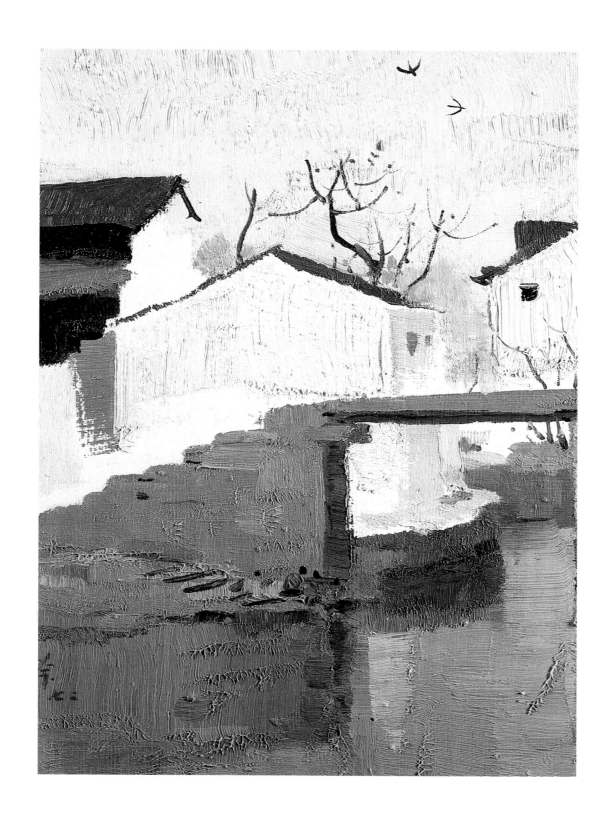

Hometown of Lu Xun, 1972
Oil on Board, 12 1/2 x 9 inches

Wu Zuoren

"The Chinese character I created as the symbol for the Hefner Collection represents the dragon which stands for unlimited power and constant change. Even though it was made with ink and brush, I have a long history as an oil painter and I believe that Chinese contemporary artists should continue to explore new techniques of painting. There's nothing wrong with looking to the West, but they should understand themselves and their unlimited power first."

Dragon Character, 1986
Ink on Rice Paper, 40 x 40 inches

Xu Mangyao

"My paintings have nothing to do with politics as even my colleagues have suggested. I saw a life-size sculpture of a woman in a museum in Italy and it seemed so real that I wanted to paint the same subject. I saw some relationship between a wall and the human body because of this sculpture and I made a painting entitled *My Dream*. It was the first in a series of four works dealing with figures passing through walls."

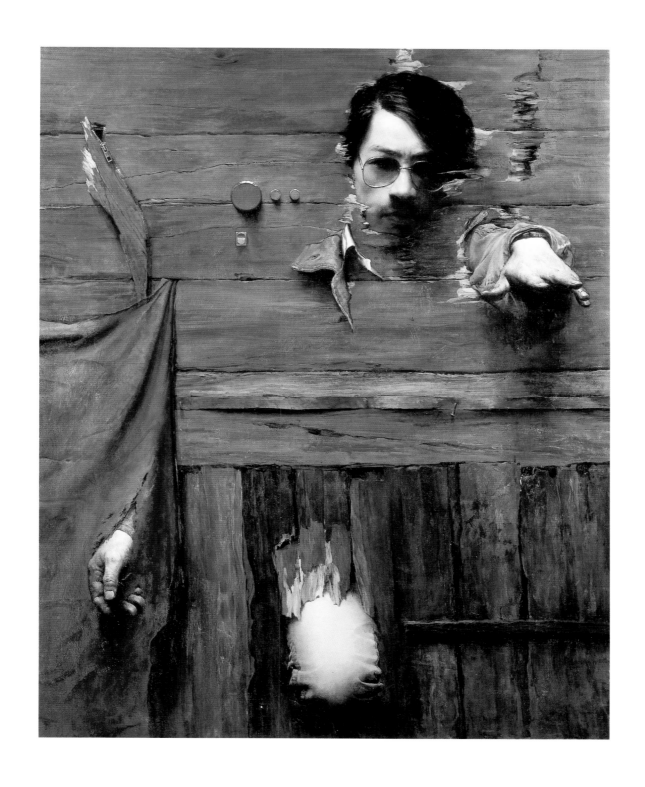

Young Scholar, 1989
Oil on Canvas, 39 x 32 inches

"*Young Scholar* and *Young Woman* are from the *My Dream* series. At first I was doing the paintings for pleasure, but later on, I found it was interesting to express a connection between Chinese and Western culture through the use of things like the American credit card or the French franc you see in the wall in *Young Woman*. When I begin a painting, I may make photographs of my models. From the photographs I make sketches, and from the sketches, the completed works."

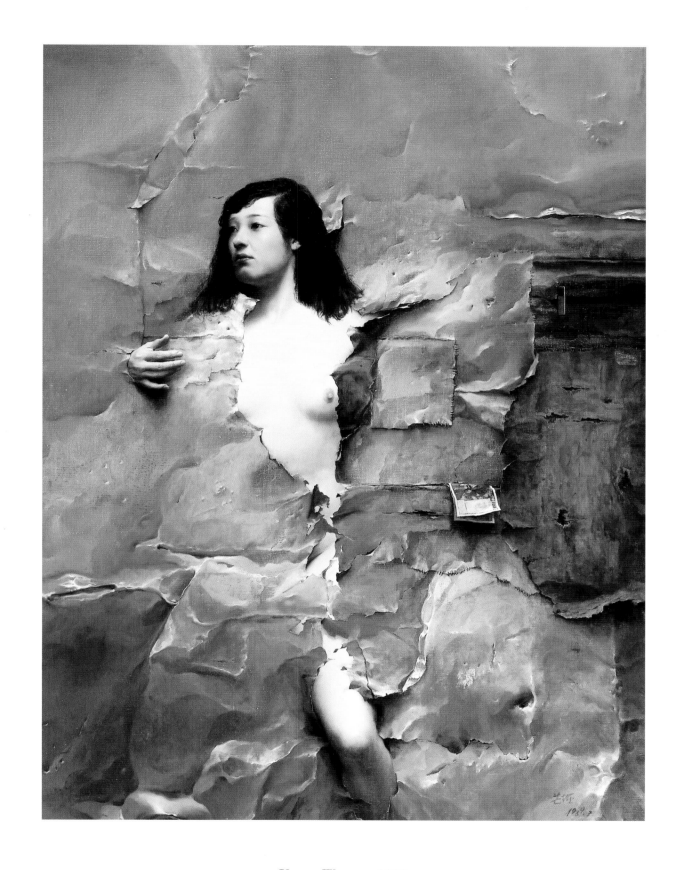

Young Woman, 1989

Oil on Canvas, 64 x 48 inches

Yang Feiyun

"My wife is not my only subject although she is my most constant one. The portrait of her with the dog began when I made a trip with my art students to study and paint minorities and the specific costumes people who live in different places wear. I borrowed the dress she is wearing in this picture from a woman I met. At the time of the sitting, we had a dog in our home and while I was painting the portrait, my wife picked up the dog and I saw the scene develop."

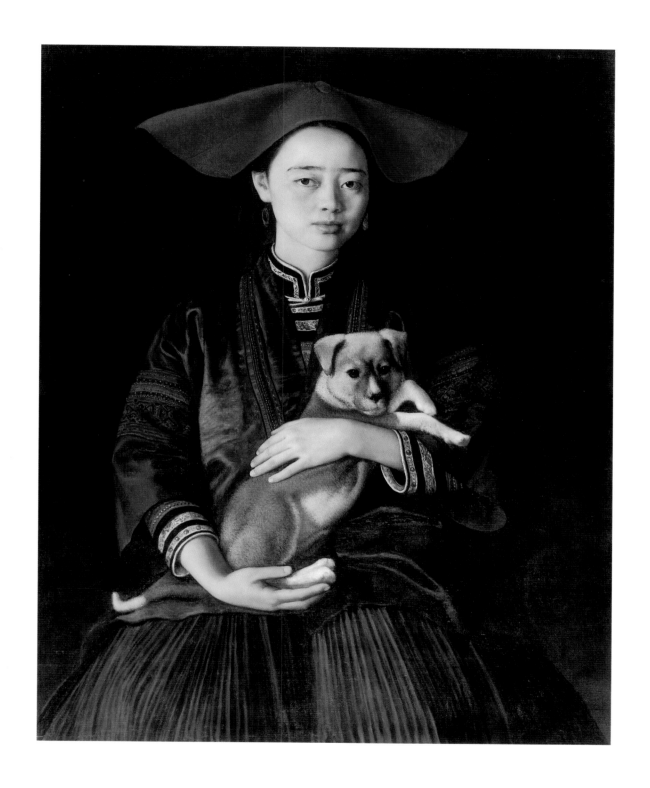

Artists' Wife with Her Dog, 1989
Oil on Canvas, 39 x 31 inches

"The picture called *Instantaneous Static* is another example of my fascination with gestures and my desire to stop time. I was walking through our home one day and saw my wife simply put her hand to her eye and hold it there. I don't know why, but I remembered this gesture and wanted to paint it. I would like the viewer to be able to identify my subjects with everyday life and recall personal, private moments they may relate to."

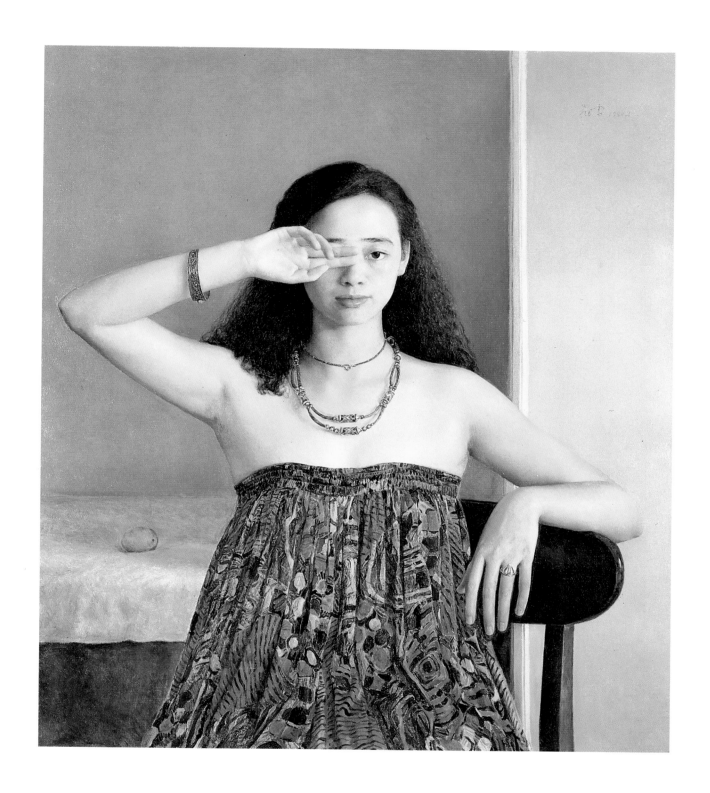

Instantaneous Static, 1990
Oil on Canvas, 34 x 30 inches

Zhai Xinjian

"My painting of a nude woman was made in an instructors training class at the Central Academy of Fine Arts in Beijing. The young woman in the picture was the model for the class and I was actually attracted to the Oriental shape of her face. I liked her whole body though and I tried to use a certain shade and color of light to emphasize her Oriental style. When I made this, there was no problem with painting nudes. Prior to the end of the Cultural Revolution however, it would not have been encouraged."

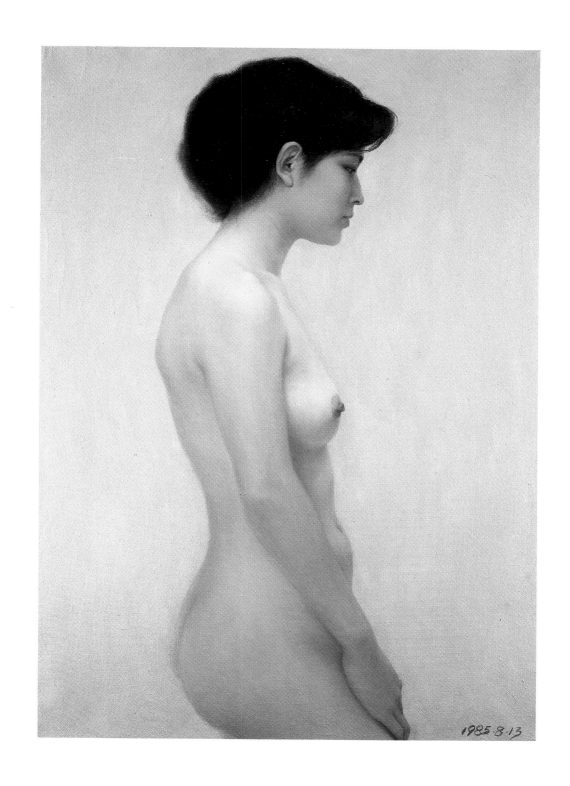

Nude, 1985

Oil on Canvas, 38 x 20 inches

"*Ancient Mural* is a portrait of my wife. The school where I teach organized a trip to a temple that has many beautiful mural paintings and at that time, my wife was editing a book on mural painting. I did her portrait in front of one of the murals for her book."

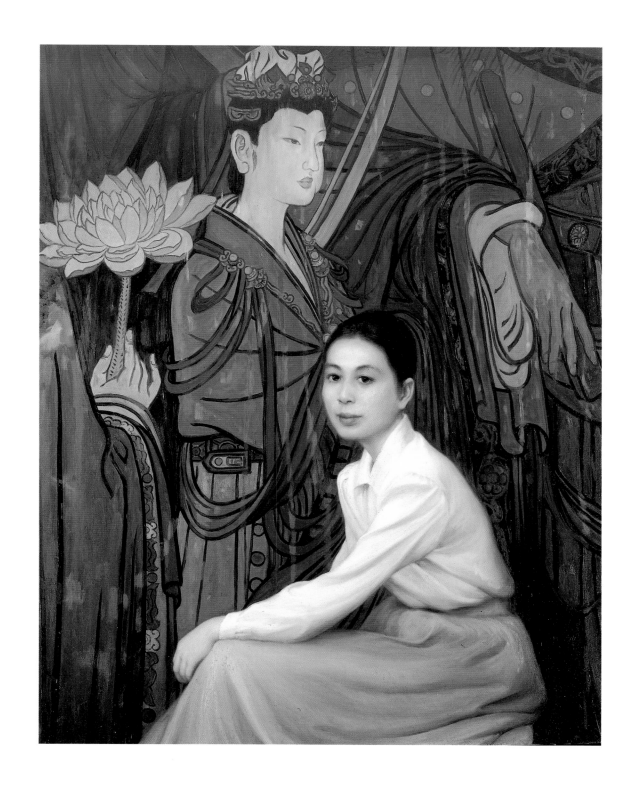

Ancient Mural, 1987

Oil on Canvas, 40 x 32 inches

Zhan Jianjun

"Both *Old Man from the North* and *Tajik Old Man* were painted while I was on a trip to Xinjiang province. I made them as demonstrations for a class I taught so that is why they are painted on board. I was interested in these subjects because they are so very different from those I would find in Beijing. We do not have a very long history of oil painting in China, but we have a long cultural history so we can use Western techniques to show Chinese subjects. It is my hope that my students learn the basic skills of painting and combine what they know about their society towards a development of Chinese oil painting."

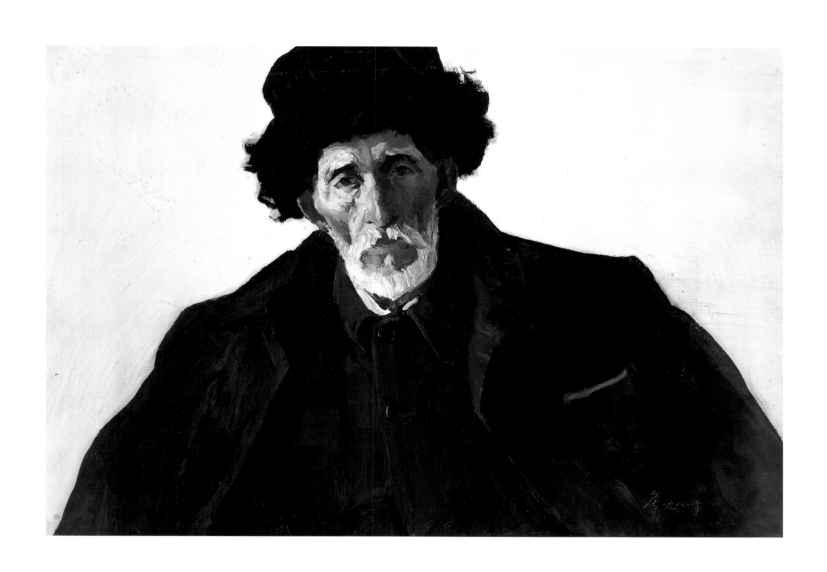

Old Man from the North, 1981

Oil on Board, 21 x 30 inches

Tajik Old Man, 1981

Oil on Board, 21 x 19 inches

Artists' Biographies

Ai Xuan

Born in 1947 in Hebei province, Ai Xuan credits his father, Ai Qing, one of China's most famous poets, for his early interest in art. Xuan graduated from the Central Academy of Fine Arts Preparatory School in 1967. His further education was interupted by the Cultural Revolution and between 1969 and 1973, he was sent to hard labor on a military farm in Tibet. He has however, stated that this experience provided him with subject matter for most of his best paintings. He won the Silver medal at the Second National Exhibition of Young artists in China in 1981 and since then has gone on to become one of the most recognized painters of the post-Cultural Revolution period. His work regularly sets record prices at auctions in Beijing and Hong Kong. A member of the Chinese Artists' Association, he is also a full professor at the Beijing Painting Institute.

Cai Jipin

Cai Jipin was born in 1947 in Tieling City, Liaoning province. He began studying art on his own at the City Youth Palace and later by correspondance through the Qingdao City Art School, Shandong Province. During the Cultural Revolution, he was assigned to teach painting at a farm school and then was placed in charge of stage design for the city art group. From 1978 to 1986, he served as a professional painter at the Tieling City People's Art Exhibition Hall. In 1985 he was accepted as a member in the Chinese Artist's Association. From 1987 to 1989, the artist worked at the Dalian City People's Art Center where he studied under French painter Clause Evir. On April 12, 1989, Mr. Cai was reported missing and has not been heard from since. His work has been reproduced in numerous Chinese art periodicals and is a part of the permanent collection of the China Art Gallery.

Cao Li

A multi talented artist and musician, Cao Li was born in 1954 in Guizhou, Guiyang province where he attended primary and middle school. In the early 1970s, he began a private study of oil painting, although assigned an official Cultural Revolution era job as a steel beam contruction worker. In 1978, he entered the Central Academy of Fine Arts, Beijing, graduating from its Mural Painting Department in 1982 and becoming a teaching assistant there. In 1988, he held his first one-man exhibition at the Central Academy and continued to work at the school in the capacity of lecturer. He took a one year sabbatical in 1991 to study privately in Europe, traveling in France and Spain. When he returned in 1992, he became an associate professor in the Mural Painting Department. He has had two monographs published on his work and exhibits his paintings frequently throughout Asia and Europe.

Cao Liwei

Born in 1956 in Liaoning province, Cao Liwei has always been interested in landscape painting. From 1978 to 1982, he was a student at the Central Academy of Fine Arts, Beijing, where he won first prize at his graduation exhibition. From 1981 to 1985, he traveled extensively throughout the Qinghai and Gansu Provinces and into Tibet. In 1985, he was awarded the silver medal at the National Exhibition of Fine Arts. His work has been shown in Canada, France, Japan, and the United States. He currently resides in Southern California.

Chang Qing

Chang Qing was born in 1965 in Chengdu, Sichuan province and began painting at the early age of four. He graduated from the highschool of Sichuan Academy of Fine Arts in 1984 and from the Department of Oil Painting of the Zhejiang Academy of Fine Arts, Hangzhou in 1989. His work has been included in major national exhibitions including the Shanghai First Chinese Oil painting Exhibition, the Seventh National Art Exhibition and the First Annual Exhibition of Chinese Oil Painting, Hong Kong. He is currently an instructor in the Oil Painting Department of the China National Academy of Fine Arts, Hangzhou.

Chen Qiang

Born in Beijing in 1957, Chen Qiang studied at the Central Academy of Fine Arts and went on to teach there through the mid-1980s. He moved to the United States in 1986 living in both Laguna Beach and New York City, while exhibiting his oil paintings of Tibeten subjects internationally. He currently shuttles between Beijing and New York and has devoted his efforts of the past five years to filmmaking. His latest project, *Agepass*, involves a multimedia presentation of his documentation of life along Chinas' famous Yellow River.

Chen Yanning

Chen Yanning was born in 1945 in Guangzhou, Guandong province and attended the Guangzhou Academy of Fine Arts, graduating in 1965 and remaining there for further study through 1986. He was a professional artist at the Guangdong Painting Institute, a member of the Council of the Chinese Artists' Association, and a member of the Guangdong Literature and Art Union. In 1987, he accepted an invitation from Robert Hefner to come to the U.S. for the opening of the Harkness House Exhibition. He has remained here ever since, developing an impressive career as a commissioned portrait painter. Chen has traveled extensively and has been a guest artist in Australia, Brazil, Great Britain, France and the United States, presenting one-man exhibitions in all of these countries. His work has been acquired by major museums including the Chinese National Gallery, the Museum of Chinese History and the West Australian National Gallery. Today, he and his family live in New Jersey.

Chen Yifei

Born in Zhenhai County, Zhejiang province in 1946, Chen Yifei is considered a son of Shanghai as he has spent most of his life there and is today, one of its most recognized artistic figures. He graduated from the Shanghai Fine Arts Academy in 1965 and went on to study at the Shanghai Institute of Painting, where he became the head of the Oil Painting Department in 1970. Throughout the 1970s, he received many honors at the National Art Exhibitions in Shanghai and Beijing. In 1980, he took a big chance and moved to New York to work as a professional painter while studying Western art. During his first year in the U.S. he had paintings shown at the New York International Art Exhibition and the New England Center for Contemporary Art. Throughout the 1980s, he exhibited in group shows at Boston City Hall and Smith College and was given one-man shows at the Corcoran Gallery of Art, Washington, D.C. and at Hammer Galleries, New York. In the1990s, the artist concentrated on commissioned pieces including an oversize portrait of Dr. Armand Hammer for the Hammer Art Gallery and Cultural Center, Los Angeles and a major painting for the World Federation of United Nations Association entitled *Bridge of Peace*. During this time, he also became a motion picture director. His first theatrical release entitled *Evening Liaison* was selected for the Cannes Film Festival in 1995. In December, 1996, a major retrospective entitled *The Homcoming of Chen Yifei* premiered at the Shanghai Museum prior to circulating internationally. Today, Chen divides his time between Shanghai and New York.

Guo Chunming

Guo Chunming was born in Nanjing, Jiangsu province in 1963. He graduated from the Nanjing Art Institute in 1988 and went to work at the Nanjing Publishing House as an editor. He is a member of the Jiangsu Artists' Association and the Council of Oil Painting Studies of the Nanjing Artists' Association. Guo has had exhibitions in Japan, Malaysia, Thailand, Singapore, Hong Kong, Canada and the United States. He lives in Nanjing.

He Daqiao

Part of the new generation of painters who have chosen to work in a neo-classical style, He Daqiao was born in 1961 in Harbin City, Heilongjiang province, He entered the People's Liberation Army Art Institute in 1976 and graduated from the Fine Arts Department in 1983. Following graduation he worked as a stage designer for the Song and Dance Ensemble of the PLA General Political Department, leaving in 1992 to work on his own as a professional artist. In 1984, his painting *The Warm Sunshine* won the Prize of Excellence at the Sixth National Exhibition, Beijing. In 1987, his *Still Life* won the Prize of Excellence at the First China Oil Painting Exhibition and in 1992, *Untitled* won the Prize of Excellence at that year's Chinese Oil Painting Exhibition, Beijing. He currently resides in Beijing where he works as a professional painter. A monograph of his work was produced in 1993.

He Datian

He Datian was born in 1949 in Hunan province. He is an artist with the Hunan Provincial Federation of Literary and Arts Circles and is a council member of the Hunan Oil painting Committee and the Chinese Artists' Association. He was given his first large one-man show at the China National Art Gallery in 1988 where he exhibited his *Doors* series. He is currently living in southern California.

He Jiangcheng

Born in Guangzhou, Guangdong province in 1957, He Jiangcheng graduated from the Guangzhou Academy of Fine Arts with an M.A. degree in 1987. He remained there for several years as an instructor. He now lives in California and is pursuing a career as a professional painter.

He Kongde

He Kongde was born in Xicheng County, Sichuan province in 1925. An early interest in art, prompted him to study traditional brush painting in primary school. In 1943, he entered the Fine Arts Department of the State Chongqing Normal University and in 1945, transferred to the the Sichuan Provincial Art School in Chengdu to learn Western gouache techniques from instructors who had studied in France. After graduation in 1947, He joined the Chinese People's Volunteer Army and fought in the Korean War. In 1955, he went to Beijing and was accepted in the Central Academy of Fine Arts where he studied under Russian instructors. For over 40 years, he has concentrated on themes depicting Chinese modern history. He is a Standing Council Member of the Chinese Artists' Association and was Deputy Director of the Oil Painting Commission. He is retired and lives in Beijing.

Jian Feng

Jian Feng is a native of Sichuan province and a graduate of its Academy of Art. His painting *The Wish, 1984* was an award winner at the Sixth National Exhibitioin, Beijing. He currently lives in Paris where he is a professional artist.

Kuang Jian

Kuang Jian was born in 1961 in Hefei City, Anhui province. He began studying art privately in 1974, and in 1979 was accepted into the Academy of Arts of the People's Liberation Army, Beijing. Since his graduation in 1983, he has been an art director for the Army Day Movie Studio, Beijing. He was awarded the Bronze prize at the Seventh National Exhibition in 1989 and has participated in shows in Australia, Hong Kong, Taiwan, Japan and Germany. He currently resides in Beijing.

Li Binggang

Born in Xinmin County, Liaoning province in 1947, Li Binggang studied at the Fine Arts Department of the Liaoning Normal University of Art from 1964 to 1968. His work was exhibited at the Fourth, Fifth, Sixth and Seventh National Exhibitions, Beijing between 1974 and 1989. His painting, *People's Own Army, 1984*, won an award at the Sixth National Exhibition. In 1982, Li became a professional painter in the Cultural Department of the Shenyang Division Army, Shenyang City where he currently lives.

Li Kai

Strongly identified with his paintings of the Forbidden City, Li Kai was born in Beijing in 1947. He graduated from the Central Academy of Fine Arts Preparatory School in 1967 and at the beginning of the Cultural Revolution, was sent to a remote region near the Huliu River to work at hard labor. In 1974 he was permitted to return to Beijing and served as a restorationist at the Forbidden City where he remained past the Cultural Revolution, until 1982. Since that time, he has supported himself solely as an artist. He has had numerous one-man exhibitions throughout China and in France and Algeria and his works are sold regularly at auction. He lives in Beijing.

Li Xiushi

Born in Jinzhou, Liaoning province in 1936, Li Xiushi graduated from the Jinzhou Teachers' Training School in 1954, then entered the Oil Painting Department of the Central Academy of Fine Arts, Beijing in 1956. Following graduation in 1961, he worked as a professional painter in the Heilongjiang Artists' Association, establishing its Oil Painting Research Club in 1981. In 1988, Li went to work for the China Worker's Publishing House and in 1989, established the Research Institute of Chinese Fine Arts. His paintings have been exhibited internationally and are in the collections of the China Art Gallery and the Museum of Chinese History, Beijing. He currently resides in Beijing.

Lin Hongji

Lin Hongji was undoubtedly influenced by the intriguing landscape of his homeland in the semi-tropical area of Guangzhou in Guangdong province. Born there in 1946, he graduated from the Guanzhou Academy of Fine Arts in 1970. He won the Bronze medal at the Seventh National Exhibition, Beijing in 1989 and his works have been exhibited in numerous international group shows over the last ten years. He is currently Deputy Director of the Guangdong Painting Studio, a member of the staff council of the Chinese Artists' Assoociation and a member of the Chinese National Association of Artists. He resides in Guangzhou.

Lui Aiman

By his own explanation, Lui Aiman was born in 1948, while his parents were traveling in an unidentified part of Northeast China. He grew up in Xian and attended the attached school of the Xian Academy of Fine Arts. While the Cultural Revolution interupted his education for ten years, he resumed his studies in 1977, and graduated from the Xian Academy of Fine Arts where he is now an instructor in the Oil Painting Department.

Luo Erchun

Born in Hunan province in South Central China in 1929, Luo Erchun graduated from the Suzhou Fine Arts Institute in 1951. He served as editor for the People's Publishing House of Fine Arts and from 1959 to 1964, was an attending lecturer at the Fine Arts Department of Beijing Art College. He has lectured extensively on oil painting at academies throughout China and makes yearly trips to Paris to paint and plan exhibitions of his work. He is currently a professor in the Oil Painting Department at the Central Academy of Fine Arts, Beijing.

Luo Zhongli

Luo Zhongli was born in Chongqing in 1948. He graduated from the Oil Painting Department of the Sichuan Academy of Fine Arts in 1982 and remained there for one year as an instructor. From 1983 to 1986, he studied at Antwerpen Royal Fine Art College, Belgium where he obtained a M.A. degree. His much reviewed painting *Father* won first prize in the *Second National Youth Fine Art Exhibition*, Beijing, 1982 and became a part of the collection of the China National Gallery. *Father* was exhibited for the first time together with *Father II* and *Spring Silkworms* at the *Contemporary Oil Paintings from the People's Republic of China*, Harkness House Exhibition in New York, in April of 1987 where they received great acclaim. Mr. Luo has had one-man exhibitions of his work in Belgium, Paris, Hong Kong, Taiwan, at Harvard University and in Chicago. He is currently an associate professor at the Sichuan Academy of Fine Arts, Chongqing as well as a member of the Standing Council of the Chinese Artists' Association.

Mao Lizi

The artist who is known professionally as Mao Lizi, was born in Shanghai in 1950 under the name Zhang Zhunli. His family moved to Beijing when he was three, and Mao began studying painting on his own at eleven. He graduated with a Master of Arts degree from the Oil Painting Department of the Central Academy of Fine Arts, Beijing in 1987. A founding member of the infamous *Stars* group of avant-garde artists, he has exhibited his work in numerous museums and galleries internationally since the early 1980s. Today, he divides his time between Paris and Beijing, working as a professional painter.

Wang Yidong

Wang Yidong was born in the Yimeng area of Shandong province in 1955 and received a degree from the Fine Arts Department of Shandong Art School in 1975, after which time his graduate studies were interrupted by the Cultural Revolution. In 1982 however, he graduated from the Oil Painting Department of the Central Academy of Fine Arts, Beijing. His work has been exhibited worldwide from France to Japan, New York to Hong Kong, Canada to Italy, and in countless shows throughout China. He was one of six artists invited to America by Robert A. Hefner III for the opening of the Harkness House Exhibition, New York in April of 1987. Following that show, he lived in Oklahoma for one year, but the need to paint the subjects he is closest to brought him home to China. He is currently an associate professor at the Central Academy of Fine Arts.

Wang Huaiqing

Wang Huaiqing is from a family of artists and consequently began his study of art at a very early age. He was born in Beijing in 1944 and entered the Central Academy of Fine Arts Preparatory School at eleven. From 1964-1966 he was a student of Wu Guanzhong's at the Central Academy of Arts and Crafts. Following the Cultural Revolution (1966-1976), Wang resumed his studies at the Central Academy of Arts and Crafts, graduating with a Masters degree in 1981. In 1983, he joined the Beijing Painting Academy as a professional artist. In 1987, at the invitation of Robert A. Hefner III, he came to the United States where he remained for a year. During this time, he was an instructor in the art department of Oklahoma City University. Currently, Wang lives in Beijing. His paintings have been acquired by the China National Gallery and collectors worldwide. His daughter Tian-Tian is also an artist.

Wu Dayu

Considered one of the fathers of Chinese oil painting, Wu Dayu was born in Yixing County, Jiangu province in 1903. He began studying painting privately in 1909. In 1918 he went to Shanghai to study under Zhang Yuguang and in 1920 became an editor for *Shen-Bao* (Shen News). In 1922, he was sent to Paris to study Western oil painting techniques with the idea of returning to China and teaching in the academies. While in Europe, he organized a Chinese artists' association called the Phoebus Society which sponsored one of the first, major European Chinese painting exhibitions held in Strasbourg, France in 1924. Returning to China in 1927, he taught at the Shanghai Art School and in 1928, co-founded the National Art Academy, Hangzhou, becoming the first director of its Western Painting Department. He created the Art Movement Society and its influential publication, *Apollo*. Wu continued to teach at the National Art Academy which was moved to Yuanling, Sichuan province in 1937 following the Japanese invasion. In 1950, he left the school to work privately. Returning to Shanghai, in 1965, he became Vice-President of the Shanghai Painting Studio and a member of the General Council of the Chinese Artists' Association. During the Cultural Revolution, Wu's work was denounced by the Chinese government and consequently much of it was destroyed. He died in Shanghai in 1988. Today, examples of his oil paintings are extremely rare.

Wu Guanzhong

Wu Guanzhong was born in Yixing, Jiangsu province in 1919. He first studied painting under Lin Fengmian and Wu Dayu at the Hangzhou Academy of Art in 1936. Following his graduation in 1942, he taught at Chongqing University. In 1946, he was awarded a scholarship to study in France at the Ecole National Superieure des Beaux-Arts. He also studied art history at the Ecole du Louvre. Returning to China in 1950, Wu taught at the Central Academy of Fine Arts, Beijing, Qinghua University and Beijing Normal Academy. From 1964, through the Cultural Revolution, he was persecuted by the government and sent to hard labor. He continued to paint in oil however and held his first major one-man show in 1979 at the China National Art Gallery. As a representative of the Chinese Artists' Association, he has lectured extensively on Chinese modern painting and his work has been exhibited internationally. In 1990, Wu was awarded the Grade d'Officer des Arts et des Lettres by France's Ministry of Culture. In 1993 a major retrospective of his work was presented at the British Museum, London, and again in 1995 at the Hong Kong Museum of Modern Art. He currently resides in Beijing where he is a professor at the Central Academy of Arts and Crafts.

Wu Zuoren

Although he is a most respected brush and ink painter, Wu Zuoren also distinguished himself as an oil painter in China as early as the 1920s. Born in 1908 in Jingxian County, Anhui province, Wu studied at Shanghai University of Fine Arts in 1927, Shanghai South China Academy of Fine Arts in 1928, and Nanjing Central University in 1929. He moved to Paris in 1930 and entered the Academy of Fine Arts of France, and later went on to the Royal Academy of Fine Arts, Belgium. Returning to China in 1935, he taught in the Department of Fine Arts at Beijing's Central University. In 1949, he became professor of art at the Central Academy of Fine Arts, Beijing and later, Dean of Studies and Vice-President of the Academy. He has served as President of the Chinese Artists' Association and Vice-President of the China Federation of Literary and Art Circles. His paintings have been exhibited and collected internationally. He currently lives in Beijing.

Xu Mangyao

Xu Mangyao, whose hyper-realist figurative works have brought him world-wide attention over the past decade, was born in Shanghai in 1945. He began his study of art at the Zhejiang Academy of Fine Arts Preparatory School when he was seventeen. In 1980, he graduated with a Masters degree in Fine Arts from the Zhejiang Academy where he remained as an instructor through 1984. From 1984 to 1986, he studied at the Pierre Cardin Studio, Paris. His work has been exhibited in Europe and the United States. He is currently a professor and artist in residence at the China National Academy of Fine Arts, Hangzhou.

Yang Feiyun

Born in 1954 in Baotou, Innermongolia, a long way from the recognized centers of art, Yang Feiyun came to Beijing to study and graduated from the Central Academy of Fine Arts in 1982. He then went on to became a lecturer in the Department of Design at the Central Academy of Drama. In 1984, he was appointed lecturer in the Oil Painting department of the Central Academy of Fine Arts and is currently an associate professor there. Since the 1980s, he has also traveled extensively showing his work in over twenty exhibitions world-wide including; the *Japan Exhibition of Asian Art*, Bangladesh, 1986, the *Invitational Exhibition of Eight Famous Artists*, Guilin, 1987, *Contemporary Oil Paintings from the People's Republic of China*, Harkness House, New York, 1987, the *Seventh National Fine Arts Exhibition, Beijing*, 1989, and the *'91 Biennial of Chinese Oil Painting*. In additon to winning numerous awards, his paintings are included in the collections of the Chinese National Gallery and the Gallery of the Central Academy of Fine Arts, Beijing as well as the Fushan Museum, Japan.

Zhai Xinjian

Recognized for his nudes and portraits of ballet dancers, Zhai Xinjian was born in Tianjin City, close to Beijing in 1950. He entered the Middle School of the Central Academy of Fine Arts, Beijing in 1966, however his education was interupted by the Cultural Revolution and he did not resume his studies until 1977. He graduated from the Central Academy of Fine Arts in 1981 and he is now a professor in its Oil Painting Department.

Zhan Jianjun

A long-time professor of the Central Academy of Fine Arts, Zhan Jianjun was born in Beijing in 1931. He began his own education at the Central Academy in 1949, graduating in 1957 with two degrees. He has traveled extensively and his work has been exhibited in Africa, France, Hong Kong, Japan and Russia. Zhan is represented in numerous private and museum collections including the China National Gallery, the Chinese Revolutionary History Museum and the Chinese Military Museum.

Acknowledgements

I want to express my sincere thanks and deep gratitude to all those who have assisted with and made possible The Hefner Collection of Contemporary Chinese Art and this *Through An Open Door* exhibition of oil paintings, starting with the Chinese people whose heart and courage, ancient culture, and enthusiasm for change created this very special moment in history; to The Honorable Deng Xiaoping, whose reforms unleashed the monumental socioeconomic change we are witnessing today, and whose government established the "Open Door" policy through which we and "our" artists openly traveled; to all the past, present and future Chinese artists who have and undoubtedly will maintain China's great tradition in the arts; to the artists of this collection, whose individual history, perseverance, passion, talent and creativity formed these works; to the members and leaders, past and present, of the Chinese Artists' Association, who were instrumental in my introduction to contemporary Chinese oil painting; to Ambassador Han Xu, for his courageous participation in "opening" China's door and his embracing and attending the Harkness House Exhibition; to his widow, Madame Ge Qiyun, whose beautiful calligraphy of *Through An Open Door* travels with the collection; to his son Han Weiquiang, and daughter-in-law, Jie Yang, who were essential to our research for this publication and assisted with filmed interviews of the artists; to Wu Zuoren, a highly respected father of oil painting and master calligrapher, for his superb rendition of the dragon character, our fitting symbol of this collection; to Patricia Patterson and John Robinson, who each traveled with me on defining and memorable art collection pilgrimages; to Shelley Drake Hawkes, who added a fresh dimension to our job of selecting paintings for the Harkness House Exhibition and is now completing her Ph.D in Modern Chinese History; to Roger D. Creelman, Director of Hefner Galleries, and consultant to the collection, for his many years of loyal participation; to Fan Dian for his critical essay for this book; to the GHK staff – past and present – Bettye Ames, Janet Brewer, Bob May, Jane Rider, Kathy Wade, Tina Owens White, and all who have kept this many faceted project moving forward; to Lisa Lai (Lai Xiao Yan) and Mark Ye (Ye Chang Feng), whose organization, translation, dedication and travel to the art outposts throughout China was fundamental to the organization and completion of this collection; to Eddy Jones and her family, whose charity built the Fred Jones Jr. Museum, and Tom Toperzer, its Director, and staff who hosted the premiere of *Through An Open Door*; and last and certainly not least, to Jon Burris, Curator of the Hefner Collection, for his vast talent, superb photography, hours on end of video conversations with the artists, continuing thoughtful input since our beginning at Harkness House, and organization of this book, the *Through An Open Door* exhibition and CD ROM of the collection.

Robert A. Hefner III